A–Z

OF

ST HELENS

PLACES - PEOPLE - HISTORY

Sue Gerrard

AMBERLEY

Acknowledgements

I would like to thank and acknowledge all the people and organisations that have helped during the writing of this book. These include Robert Evans for photographs, St Helens Local History & Archives, Friends of Carrington Shaw, Steve Wainwright, Bob Roach, Brian Leyland, Claire Rigby, Chris Coffey, Mary Presland and everyone who contributed their time and knowledge to this book.

I have carried out extensive research and to the best of my knowledge the facts in the book are correct at the time of publication, but I apologise in advance if any errors have inadvertently crept in. I also apologise if I have not included any of your favourite items, but the town is so rich in history it was not possible to include everything.

First published 2022

Amberley Publishing
The Hill, Stroud, Gloucestershire, GL5 4EP
www.amberley-books.com

Copyright © Sue Gerrard, 2022

The right of Sue Gerrard to be identified as the Author of this work has been asserted in accordance with the Copyrights, Designs and Patents Act 1988.

ISBN 978 1 3981 0979 7 (print)
ISBN 978 1 3981 0980 3 (ebook)

British Library Cataloguing in Publication Data. A catalogue record for this book is available from the British Library.

Typesetting by SJmagic DESIGN SERVICES, India. Printed in Great Britain.

Contents

Introduction

Although St Helens only became a town in the mid-nineteenth century it has a proud history of innovation, industrialisation, invention and entertainment. This not only helped to shape the town but had a wider influence worldwide, particularly in the areas of science, industry and transport.

St Helens was originally four townships – Eccleston, Parr, Sutton and Windle – but the Industrial Revolution made it the centre of glassmaking, coal mining and copper smelting, to name just a few industries that grew here. It became a municipal borough in 1868, by which time the first navigable waterway in the country, the Sankey Canal, had opened here (in 1757) and the world's first passenger railway, the Liverpool to Manchester line, had opened in 1830. However, there was no shortage of entertainment either, with such greats as Charlie Chaplin, Vesta Tilly, George Formby and the Beatles appearing here.

In this book the history of St Helens is told through its streets and buildings, industry and people connected to the town. It tells tales of suspected witchcraft, connections with the Nuremberg trials and the influence of Florence Nightingale on the town's hospitals, as well as that of the town's industrial heritage.

Alexandra Colliery

Alexandra Colliery is an industrial heritage site in St Helens. It was opened by Pilkington Brothers to supply their glassworks with coal, and they sank this colliery in 1867. It was named after Princess Alexandra of Denmark, wife of the future Edward VII, who visited the sinking.

In November 1868, tragedy struck when a furnace providing ventilation from halfway down a shaft broke. As a result, a fire was started by the live coals and smoke began to enter the pit. The underground manager, the under looker and a wagoner went to tell the miners to come out, which they did; however, this party continued further into the mine. Sadly, they did not return, and their bodies were discovered the following week.

Another tragedy happened on 22 October 1879 when Joseph Naylor, the engine man, forgot to reverse the winding engine. This caused an over-wind, resulting in the death of seven men inside a 297-metre-deep shaft. Mining finished in 1925, but one shaft was retained as a pumping pit for Ravenhead Colliery until around 1966.

Today two capped shafts around 100 metres apart can be seen near the footpath from Crossley Road. There is also a spiral heap covered in vegetation and remains of a low-level building. Coal measures can be seen exposed at the nearby railway cutting.

Anderton Monument

This monument is situated on the Cannington roundabout at the junction of St Helens Linkway and the A50 and celebrates the role played by the Ravenhead Colliery in developing the Anderton Shearer Loader.

The first use of this loader took place here in 1952 at the Rushy Park seam. It was then used at the nearby Cronton Colliery and Golborne Colliery before becoming used worldwide.

The sculpture is by Arthur Fleischman and was commissioned by Lord Robens when he was chairman of the National Coal Board in 1964. Fleischman was Slovakian and qualified as a doctor in Prague before becoming a teacher and sculptor.

The monument was commissioned for Anderton House, Lowton, Greater Manchester, which was then being built as the headquarters of the North West Division of the National Coal Board. It was installed there in 1965 and included a rotating fountain. It consists of a bust of a miner with raised arms carrying a lump of coal above his head and stands on a pedestal of railway sleepers standing on a plinth. It was moved to St Helens in December 1998. It is also known as *The Miner* and is Grade II listed.

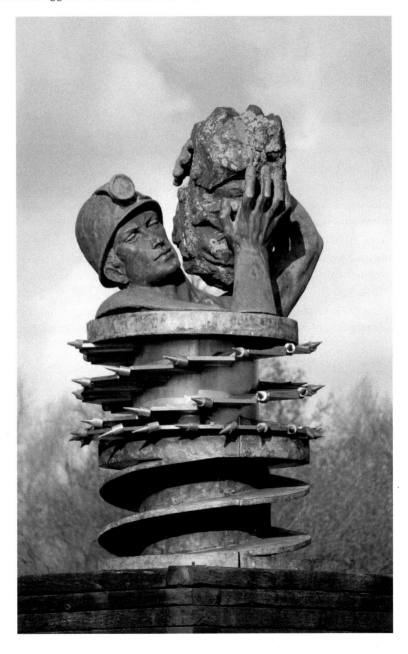

The Anderton Monument.

Beatles, The

The Beatles made their first appearance in St Helens at the Plaza, Duke Street, on 25 June 1962 and they were paid just £25. The evening was billed as 'a non-stop jive session' from 7.30 to 11 p.m., with Harry Bostock presenting his 'big beat bargain night starring the North's number one combo of The Beatles'. They were billed as being Parlophone recording artists and were just back from Hamburg. The poster also notes that it was their first ever appearance in St Helens. They were accompanied by Merseybeat group the Big Three, stars of the Jerry Lee Lewis Rockascope Show and Bob Wooler, DJ and compère, who presented the evening. The admission price was 2s and sixpence. They also played here on 2, 9 and 16 July – around a month before drummer Pete Best left and Ringo Starr took his place. Ironically, Rory Storm and the Hurricanes also played here with Ringo as their drummer.

By the time the Beatles were back for their final appearance on 4 March 1963, Ringo had joined the group. They were paid £100.

The former Plaza Building, where the Beatles played.

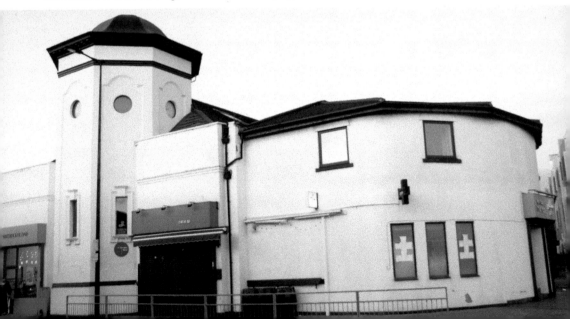

Beecham, Sir Thomas

This world-famous conductor was born in 1879 in Westfield Street, St Helens, in a house next to his family's pill factory. He was the grandson of another Thomas Beecham, founder of the Beecham Pills company.

His father, Sir Joseph Beecham, encouraged Thomas to study the piano and his first teacher was Oswald Barton, organist at Saint Mary's Lowe House Church. The factory was so successful that they moved home to Ewanville, Huyton, near Liverpool, when Thomas was seven, although Thomas retained his piano teacher. His birthplace was demolished to make way for the extension of the Beecham factory.

His passion for music continued through his school and college years and he made his debut as a conductor in 1899 with the Halle Orchestra at St Helens Town Hall at a concert to mark his father's inauguration as the town's mayor.

Beecham made his professional debut as a conductor at the Shakespeare Theatre, Clapham, in 1902 with the Imperial Grand Opera Company. Beecham went on to found the New Symphony Orchestra, the Beecham Symphony Orchestra and the Royal Philharmonic Orchestra. He was also associated with the Halle Orchestra, the London Philharmonic and the Liverpool Philharmonic. He toured the world and

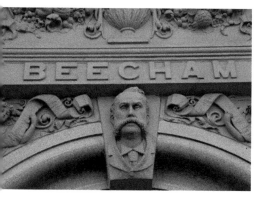

Above: The faces on the Beecham Building.

Right: The Beecham Building.

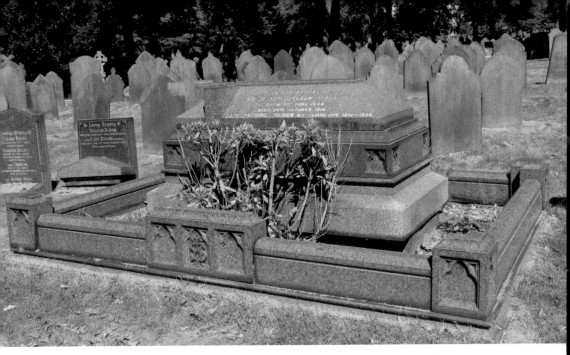

The graves of Sir Joseph and Lady Josephine Beecham, Sir Thomas' parents. This is in St Helens' Cemetery.

earned the accolade from the BBC as being 'Britain's first international conductor'. His influence on the musical world is still felt today.

He married three times: in 1903 to Utica Welles, in 1943 to Betty Humbry and finally in 1959 to Shirley Hudson. Thomas died in 1961.

Berry, Henry

Henry Berry was born in Parr in 1719/20. He was from a dissenting family and his brother John was a trustee of the Independent Chapel in the late 1720s. Berry is noted as an 'of Parr Batchellor' in a trust deed in 1742. He was the township surveyor, so his name occurs frequently in the Parr township papers.

Berry was the engineer who designed and built the Sankey Canal, or Waterway as it is sometimes known, which opened in 1757. This was the world's first modern canal, and revolutionised St Helens.

He became Liverpool's second dock engineer following the death of Thomas Steers, and built Salthouse Dock (1753), George's Dock (1785), and King's Dock (1785).

However, he maintained his links with St Helens, as in 1753 he became a trustee of the Independent Chapel. He died at his home in Duke Street, Liverpool, at the age of ninety-two and had requested his body be carried to the chapel and buried in the graveyard in his home town.

When his Liverpool home was demolished, it was replaced by the White House pub, which is now Petit Café du Coin. Berry's Lane is named after him and it is thought that Berry Street, Liverpool, could also be named after him.

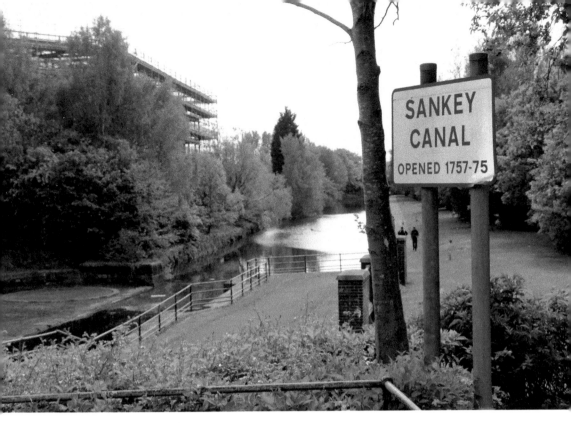

Above: The Sankey Canal sign.

Below: Berry's Lane today.

Billinge

Billinge has a long history. Flint cores dating back to 4000 BC were discovered on the south side of Billinge Hill. It is said the name comes from the ruling clan of the Varini, one of the Angle tribes who eventually displaced the native Celts in what became Lancashire. The Billingas were followers or people of Billa, a leader-king of the fourth century BC. After AD 800 nothing is known about the Billinga tribe, but it is thought they remained near Billinge Hill, forming a settlement. Billinge Hall is almost certainly on the original settlement site and was where the Billinge family stayed until 1691, when the land and family seat was sold to Francis Bispham.

Another explanation for the name is that it means 'place at the pointed hill' from the Old English *billa*, meaning 'ridge', and *ing*, meaning 'place at' or 'people of'. The name is recorded as 'Bylnge' in 1252.

Around 1777, during the development of industry, there was a concentration of nail makers in Billinge and neighbouring Winstanley.

In 1837, the parish was divided into Billinge Higher End and Billinge Chapel End. In 1974, the Higher End ward and most of Winstanley ward became part of the metropolitan borough of Wigan, Greater Manchester. Billinge Chapel End became part of the metropolitan borough of St Helens, Merseyside.

There are churches in the village that are listed buildings. The first is the Church of Saint Aidan while the second is Saint Mary's Church, built in 1828.

Billinge Hill.

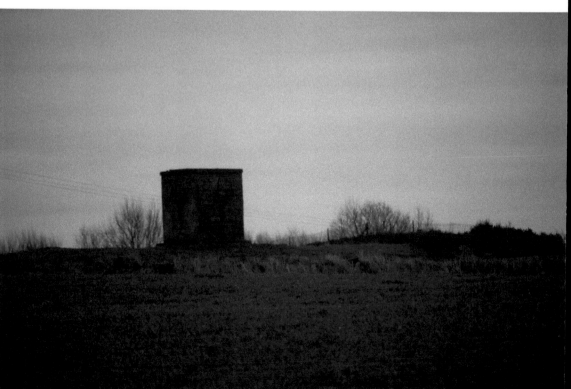

Above: St Aidan's Church, Billinge.

Below: The Eagle & Child, Billinge.

Billinge Hill, also known as Billinge Lump, is the highest point in St Helens and Merseyside, standing at 179 metres or 587 feet. On a clear day Snowdonia, Winter Hill, Manchester, Derbyshire Peaks, Blackpool Tower, Widnes, Runcorn and even the telescope at Jodrell Bank can be seen. It is one of the 176 hills graded as a Marilyn in England.

On top is an eighteenth-century beacon tower originally built as a summer house for Winstanley Hall. It was used by the Royal Observer Corps and there was a bunker there. During and after the Second World War it was used for aircraft observation, and the bunker was to be used to monitor the location of nuclear blasts and fallout over Lancashire in the event of a nuclear blast. This post was operational from 1960 to 1968.

Bold

Bold lies on the former estate of Bold Hall, which was the ancestral home of the Bolde, or Bold, family, who can be traced to this area before the Norman Conquest. The family owned this land throughout the centuries and in 1848 it covered 7,000 acres. Family members included Richard Bold, who was elected knight of the shire but died young in 1703, and his son Peter, who was elected MP for Wigan in 1727 and for the county from 1736 to 1741 and 1750 to 1760.

When Peter died in 1762 he left six daughters, with the eldest, Anna Maria, inheriting Bold and his other estates. She died unmarried in 1813, at the age of eighty-one.

The gateway and Bold Old Hall location. (Courtesy of Bob Roach)

She was succeeded by Peter, son of Thomas Patten of Bank Hall, Warrington, and his wife Dorothea, younger sister of Anna Maria Bold. As inheritor of the estates, Peter took the name Bold in 1814 and served in Parliament. When he died in 1819 his daughter Mary succeeded, who was in turn succeeded by her sister Dorothea, who married Henry Hoghton (afterwards a baronet), and he also subsequently added the Bold name to his surname.

The Bold estate was sold in 1858 by Henry and Dorothea's son, Henry Bold-Hoghton, to William Whitacre Tipping. When he died in 1889 the estate passed to Mrs Wyatt of Hampshire and after a decade was sold to a colliery syndicate and registered as the 'Bold Hall Estate, Limited'. The hall, which had once been described as 'glorious' was now dilapidated. It was taken down and Bold Colliery was opened. Later the Bold A and B power stations opened nearby, though both are now closed.

There was a workhouse in Bold after 1834, which closed in 1843 after the inmates were sent to Whiston Workhouse – now the site of Whiston Hospital.

Another interesting fact is that bull- and bear-baiting took place here until 1849, during the wakes held for three days in October. The wakes finished in 1865.

The Ladies Pool, Bold Old Hall. (Courtesy of Bob Roach)

Cannington Shaw

Today Cannington Shaw is a Scheduled Ancient Monument, classed as 'the best surviving example in the country of a tank furnace glass shop'. The site is bounded by the St Helens Linkway, Tesco superstore and St Helens RLFC rugby stadium. The rear of the site houses the former Number Seven bottle-making shop, built around 1886 and with a Siemens tank furnace heated by producer gas. Bottle making had been in St Helens since before the 1750s, with a bottle house in Thatto Heath that was bought by Francis Dixon-Nuttall and his brother-in-law, John Merson, in 1845. They built a small glasshouse near the canal terminus at Ravenhead and Merson sold his shares. Nuttall & Co. amalgamated with Cannington Shaw Seven Co. in the 1850s. This was to become United Glass Sherdley Works, which opened in 1873 and by 1889 they employed 870 people.

Cannington Shaw.

Cannington Shaw opened in 1867 under the partnership of John Cannington (a Bristol man), Edward Cannington and John Shaw, and by 1870 their furnaces made the town the national centre of bottle making. In 1892, they employed 1,880 men and women. It was the largest works of its kind worldwide.

In 1913, they amalgamated with five other bottle manufacturers to form United Bottle Manufactures Ltd, known as UGB. Soon the Number Seven shop was no longer used, and by 1918 it was just a shop. It was used as an air-raid shelter during the Second World War and survived the 1982 town centre redevelopments. Now identified as 'at risk' by English Heritage, the Friends of Cannington Shaw was founded in 2015 for the preservation and community usage of this historic building.

Carr Mill Dam

This is situated on Carr Mill Road (A571) and is one of the country's largest bodies of inland water. 'Carr' is of Norse origin and means 'marsh' or 'fen'. The dam dates back to the 1750s and was once a millpond powering Carr Mill's corn mill, which was here in the nineteenth century and owned by Lord Gerard.

The dam also played its role in the Sankey Canal navigation in the 1750s as it provided water for this navigable canal. The area was also enlarged by the London & North Western Railway during the development of the railways. The dam has a steep sluice, which was built during the 1960s to provide additional run-off for the British Sidac company.

Carr Mill Dam.

It has always been the focus of leisure, and it is recorded that in the depths of winter many people would go skating on the frozen water.

Carr Mill Dam had its own Happy Valley – a grassy slope – and there were many attractions here to cater for the numerous families who visited immediately after the Second World War.

Today it hosts competitive powerboat competitions and angling events. It has an ancient woodland and lakeside trails.

Coronation Street

There has always been a strong link between the soap, which started in 1960, and the town, with many stars visiting and some born here. One of the early cast visits was in 1962 when Pat Phoenix, who played Elsie Tanner, was the main guest at a dance in aid of Haydock Old Folk's Treat Fund at St Helens Town Hall. Later in the year she visited the Regent Pet Shop, Ashton-in-Makerfield, to knock down a pile of pennies for the Ashton branch of the British Empire Cancer Campaign.

The same year saw visits from William Roache, who played Ken Barlow, and Frank Pemberton, who played his father Frank Barlow. Both were guests at Haydock's Old Folk's Treat Committee's dinner and dance at Crompton's Recreation Club. Another visitor was Lynne Carol, who played Martha Longhurst from 1960 until the character's demise in 1964. She visited Oxley's Store, Barrow Street, to open their Ideal Home exhibition. Meanwhile, her *Coronation Street* friend Ena Sharples (played by Violet Carson) opened the first summer flower show and fête organised by the Billinge and Winstanley Horticultural Society held at Chapel Meadow, Newton Road.

More recently, Liz Dawn (Vera Duckworth) performed a cabaret show at the Knowsley Road Saints Cabaret Lounge and Lynne Perrie (Ivy Tyldesley) appeared at the Theatre Royal. Many stars visited the town to support the Royal National Institute for the Blind including Nigel Pivaro (Terry Duckworth), Anne Kirkbride (Deidre Barlow) and Geoff Hughes (Eddie Yeats), who hosted a fundraising dinner dance at the Fleece Hotel, Church Street.

Out of the current cast, Jude Riordan, who plays Sam Blakeman, was born in St Helens and still lives here.

Cropper's Hill

Cropper's Hill is situated in St Helens town centre. It was originally known as Combshop Brow because of the manufacture of ivory combs here. While industry did begin to grow around this area, in 1842 a stroll over Combshop Brow was still considered a pleasant country walk.

Cropper's Hill.

At some point its name was changed to Cropper's Hill, and at one time it was part of a turnpike road running from Liverpool and Prescot to St Helens. It is a short hill and at its foot it divides right into Liverpool Road and straight on into Westfield Street.

The Cropper's Hill mine was originally owned by the Bromilow family and ceased to be worked from the mid-1860s due to flooding.

In 1867, Cropper's Hill was the site of an omnibus accident: the vehicle overturned, killing two men and injuring seven. There were thirty men on board the vehicle, which belonged to Mr Marshall of the Van Tromp Inn and was driven by William Povey, who was one of the injured. They were all employees of Mr Jesse Varley, ironfounder, and had been on their annual trip to New Brighton. The bus overturned at 9 p.m. at a well-known accident spot. The two men who died were Charles Morris of Brook Street and William Makin (twenty-six).

In 1876, Thomas Beecham Sr moved to his new home, Hill House, situated on Cropper's Hill with his son William; his second wife, Sarah, had died.

The actor Robert Dorning was born at No. 108 Cropper's Hill in 1913 and he later moved to Pigot Street.

Crown Glass Works

This is situated in Grove Street and has a wall-mounted plaque that states, 'St Helens Crown Glass company Number 1 House'. The first crown of glass was produced in the glasshouse on this site on 14 February 1827. This company was founded in 1826

to construct a second glass factory in the area. One of its shareholders was William Pilkington and it was to become Pilkington Brothers in 1849. The site also has nineteenth- and twentieth-century workshops, offices and warehouses.

Near here, in Watson Street, by the canal, is the No. 9 Tank House, which is Grade II listed building. Built in 1883, it is the earliest remaining gas-fired continuous tank furnace in Europe.

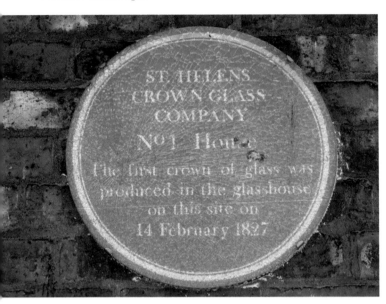

Left: The Crown Glass plaque.

Below: The Crown Glass works.

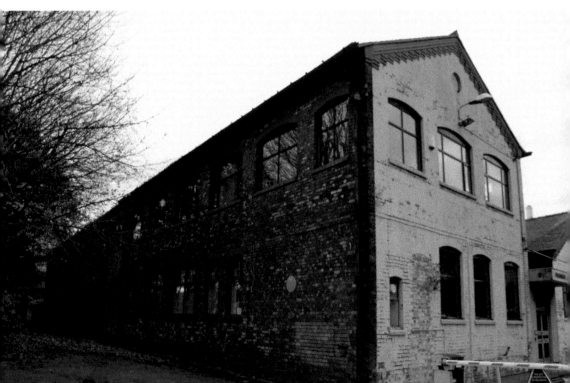

D

Daglish's Foundry

Daglish & Company, engineers and ironfounder, was situated on the aptly named Foundry Street on the side of the Sankey Canal in a heavily industrialised area of St Helens. The foundry was started in 1798 by Robert Daglish Sr (1779–1865) who came to Wigan from the North East before establishing his factory in St Helens. His son Robert (1809–83) began working here in 1830 after completing his apprenticeship with Hick & Rothwell of Bolton. In 1843, he became a managing partner, and the business became known as Robert Daglish Junior & Company.

They supplied many mines in the area and also built bridges for the Lancashire & Yorkshire Railway. They constructed the Barrack Bridge (now the Rory O'More Bridge) over the River Liffey in Dublin in 1856. They gained an international reputation for the casting and building of steam pumping and winding equipment for the mining industry. It was particularly successful in producing locomotives and bridges for the growing railway network.

The former site of the Daglish Foundry.

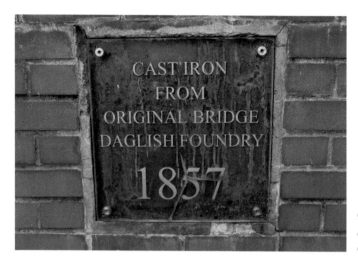

This sign noting Daglish can be found by the side of the Sankey Canal.

In the 1890s the foundry covered 25,000 square yards and employed more than 400 people. The foundry was demolished in 1939 and the old Foundry Street was demolished in the 1970s. The site of Daglish's foundry is next to the World of Glass Museum.

Deacon, Henry

Henry Deacon was born in London on 30 July 1822 and was to make a name for himself as an engineer at Pilkington Brothers. He was employed there in 1843 after he served his time at Nasmyth, Gaskell & Co.'s Bridgewater Foundry, Paticroft, starting when he was fourteen.

In 1848, he became the manager of their glass-polishing department and invented an apparatus for the grinding and smoothing of glass. The following year he became their highest-paid employee.

Deacon was also a chemist and industrialist who established a chemical factory in Widnes. He was a friend of Michael Faraday who he met at the Sandemanian Church. Faraday played an important part in the development of Deacon's life and career.

In 1851, he left Pilkington and joined John Hutchinson, alkali manufacturer, in Widnes. Two years later Deacon, with Edmond Leyland, filed his first patent for an improved manufacturing process for sulphuric acid.

Deacon was to leave Hutchinson in 1853 and become a partner of William Pilkington Jr. They established their alkali works in Widnes between the Sankey Canal and St Helens & Runcorn Gap Railway. This partnership lasted until 1855. He was then joined by his former employer Holbrook Gaskell to manufacture alkali as Deacon & Co. (later Gaskell, Deacon & Co.). His attempts to produce an ammonia soda process that would be an improvement on the Leblanc process did not succeed before they ran out of money. A Leblanc plant was installed, but it also produced quantities

of hydrochloric acid. In 1867, Deacon and Ferdinand Hurter developed a process whereby this by-product – hydrochloric acid – was converted to marketable chlorine and bleaching powder. This remained industrially important for fifty years.

In subsequent years, Deacon was to further develop the chemical industry in Widnes, where he died in 1876 from typhoid fever.

Dream

The *Dream* monument stands on the covered spoil heaps of Sutton Manor Colliery. The people of Sutton Manor wanted a monument to the former colliery, which closed in 1991. The colliery was opened in 1906 and was the last pit in England to operate steam-powered winding. When it closed the site was cleared and two mining shafts were filled and capped, but they can still be located by the vent pipes. Other spoil heaps were also converted, and they are all now part of the Forest Park.

Dream was created by Jaume Plensa, cost around £1.8 million and weighs 500 tonnes. It is 66 feet tall and resembles the head and neck of a young girl with her eyes closed in meditation. It was opened on 31 May 2009 and was funded by the Big Art Project in coordination with the Arts Council England, the Art Fund and Channel 4 Television.

The wrought-iron gates of Sutton Manor Colliery still stand as a monument to the industry.

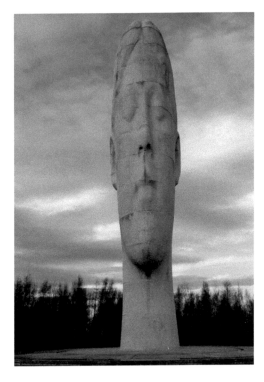

Dream.

Earlestown

Earlestown is named after Sir Hardman Earle (1792–1877), who was the chairman of the London & North Western Railway and grew up around the Railway Age. The Liverpool to Manchester line opened in 1830 and was shortly followed by the Warrington & Newton Railway, which opened in July 1831. This resulted in a new

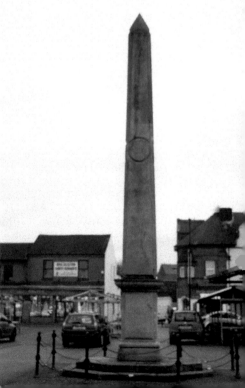

Left: Earlestown Town Hall.

Below: Earlestown market cross.

railway station: Newton Junction at the neighbouring Newton in Makerfield, now Newton-le-Willows. This station was renamed Earlestown in 1837. It also gave rise to more industry; for example, locomotive and wagon works were built near the station. Earlestown itself was then constructed in 1837 for these workers.

Earlestown became home to major wagon works. Other industries to be found here included Sankey Sugar and T&T Vicars, who produced biscuit-manufacturing equipment. The town has a popular market, which was transferred from Newton-le-Willows in 1870 and takes place in the Market Square. In the car park there is a granite obelisk that was transferred here from the grounds of St Peter's Church also in 1870. It is sometimes referred to as Market Cross.

Earlestown Town Hall, designed by Earlestown architect Thomas Beesley, was built between 1892 and 1893 by R. Neill & Sons of Manchester at a cost of £10,200. The Town Hall was designated a Grade II listed building in 2008. In 1962, the Beatles played for one night here.

In front of the Town Hall is the war memorial, which was originally erected to commemorate men from Newton-in-Makerfield who died in the Boer War. Memorials have since been added to commemorate those lost in the First and Second World Wars. It was designed by Earlestown architects Dring & Manchester and was unveiled by Lord Newton on 29 April 1905. It is also Grade II listed.

Eccleston

Eccleston was one of the four townships that, together with Windle, Parr and Sutton, were incorporated into the town of St Helens by the 1868 Act of Parliament. It is thought the name comes from *eccles*, Anglo-Saxon for 'church', and *ton*, Anglo-Saxon for 'settlement' or 'farm'. It was known as Eccleston in 1280, but as Eccliston in 1285.

The first of the Eccleston family recorded is Hugh de Eccleston, while another family member, Thomas Eccleston, fought on the Royalist side during the English Civil War. He was imprisoned and when released was killed at Warrington in 1646. The first Eccleston Hall was built around 1374, but has been rebuilt many times. The Eccleston estate was first passed to Basil Thomas Scarisbrick in 1742 and then to the Taylor family of Moston in 1812. The family is remembered for donating the land that became Taylor Park.

The area has many notable buildings, such as Christ Church (consecrated in 1838), St Thomas's (consecrated in 1839), St Mark's (opened in 1885) and the Smithy Heritage Centre. This is now a local history museum, which preserves Eccleston's heritage. Originally a blacksmith's forge, it served the busy rural community and extended to meet the growing demand, combining a wheelwright into the forge. The growth in horse-drawn transport increased the demand on its services and made it a valuable resource in Eccleston; it even served as an undertakers at one point.

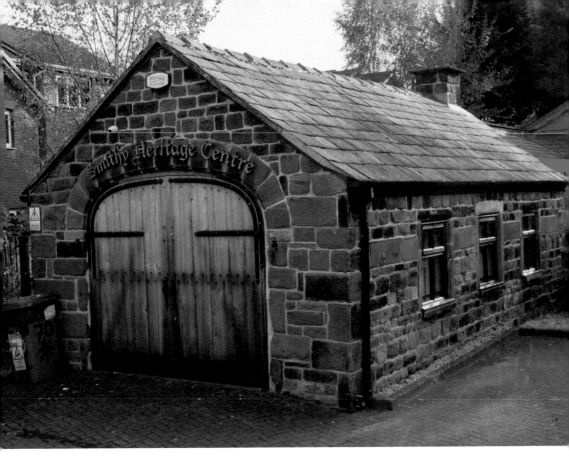

The Smithy Heritage Centre, Eccleston.

James Ranson owned the smithy in the early 1900s and was succeeded by Peter Hall in 1924, who was succeeded by his son Elias in 1957 until 1989 when the smithy closed. Today's smithy is much smaller than the original and has been relocated.

Eccleston is also the home of the natural beauty spot Eccleston Mere.

Evans, Richard

Richard Evans (1778–1864) was one of the leading names in mine ownership in the area. Originally a London printer from Paternoster Row, Evans bought the Legh family land, which housed most collieries. When Legh's partner, William Turner, died in 1847 Evans acquired his share. He then formed Richard Evans & Sons, with his sons Josiah and Henry joining the company. It remained a family business until 1889 when it became a limited company.

Haydock Colliery was one of many operated by Richard Evans and was subject to its fair share of tragedy. A firedamp explosion in May 1831 killed up to twelve workers, and a year later another explosion killed another six at the Haydock Collieries. However, the worst accident at one of their mines was at Wood Pitt on 7 June 1878 when 189 men and boys, some as young as twelve, were killed.

Richard Evans School, which closed in 1993.

In 1879, the company produced a million tons of coal from seven pits, which employed 5,900 men. Between 1869 and 1887 they built six locomotives, and in the 1930s they had their own ambulance.

This colliery, like many others, closed when the NCB (National Coal Board) came into being in 1947, and it became NCB Workshops. The site is now occupied by a supermarket and light industry.

The Evans name still lives on in Haydock with Richard Evans Community Primary School, which closed as a school in 1993, and Evans Close.

Factory Row

This row of terraced houses, set back from Ravenhead Road, was built to house the families of glass workers. The row began around 1784 as back-to-back houses, with a large house at the west end. The row was later extended eastwards and a plaque in the centre gives a date of 1854.

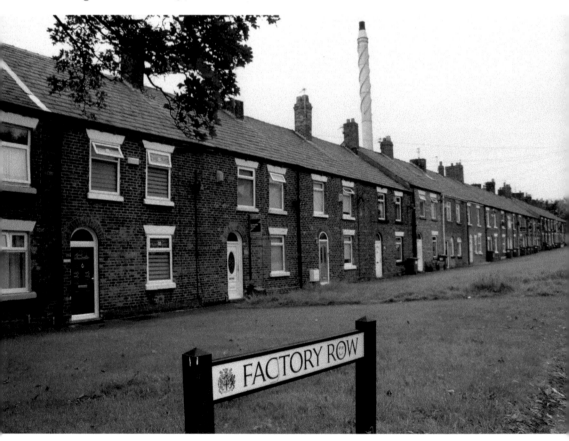

Factory Row.

Ferrie, Dr Archibald McLaren

Captain Archibald McLaren Ferrie MB, RAMC, Spec. Res. was just twenty-five when he was awarded the Military Cross for 'conspicuous gallantry and devotion to duty' on 18 February 1918. This honour was published by the *London Gazette*.

Dr Ferrie was born in Hamilton, Lanarkshire, in 1893 and he moved to St Helens in 1920. Between 1925 and 1930 his doctor's practice, Reid and Ferrie, was established at No. 2 Cotham Street. Later he was to live at Fernlea, Dentons Green Lane, and then Hamewith, Chapel Lane, Eccleston. He had a distinguished medical career and worked at St Helens Hospital and Providence Hospital; he was a factory doctor and police surgeon for thirty years. During the Second World War he was a Special Reserve in the Army Medical Corps but was not called up. However, he was medical officer to the Poison Gas Factory at Sutton and a member of the Imperial Chemical War Committee.

He married Mrs Eveline May Evans (née Else) in 1954 and the marriage lasted until her death in 1965. He died on 2 January 1992 and in 1995 St Helens Hospital named the outpatients unit Ferrie Ward.

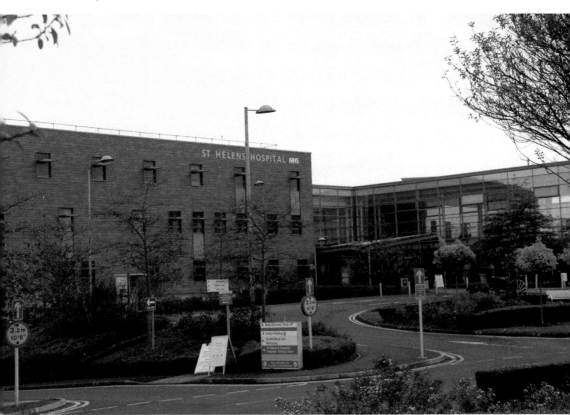

St Helens Hospital, which named the outpatients unit Ferrie Ward.

Field for the British Isles

Field for the British Isles, an installation by sculptor Antony Gormley that won the Turner Prize in 1994, was created in St Helens. Gormley, in partnership with the Tate Liverpool and assisted by students from Sutton Community High and Sherdley County Primary, their families and other volunteers, created this work. There were around 100 volunteers who worked to create the 40,000 small figures within a week in 1993. Each tiny clay figure was individually handcrafted with holes for eyes and placed side by side on a floor and viewed from the perimeter. Ibstock Factory, a brickmaking company in the town, supplied the project with 30 tons of clay that were cut and distributed by wheelbarrows and trolleys to the figure makers.

Field for the British Isles is one of the different fields that were created worldwide by Gormley and communities. In 1995, the installation was bought for the Arts Council Collection with the support of the Henry Moore Foundation and the National Art Collections Fund. It returned in June 2008 to August 2008 and was installed at St Helens College. It has also been exhibited in Salisbury Cathedral, Hayward Gallery London and Tate St Ives.

Forster, John

John Forster was born in Parr Mount in 1853 and was the founder of D&J Forster, Navigation Boiler Works, Bridgewater Street, St Helens. He served his apprenticeship as an engineer at Robinson Cook & Co., Atlas Foundry, St Helens. In 1876, he established, with his brother, a business as an ironfounder and engineer at Grove Street and then Atlas Street. In 1890, the partnership was dissolved when the lease on the Navigation Works expired and new premises opened in Atlas Street.

Forster obtained the British rights for a semi-automatic bottle-making machine, but because bottle-making factories did not want to use it he opened an area in his own works. This was so successful he took over the vacant Union Plate Glass works nearby for bottle-making purposes.

John Forster was also a local politician and was elected to the town council in 1884. He was a keen supporter of the Liberal Party and in 1895 was chosen as their candidate to stand for Parliament, but was not returned, losing by just 609 votes.

He was joined in the business by his sons Walter and William Alfred, and in 1905 Forsters & Sons became a limited company. By 1914 they were specialists in machine-made bottles, claiming to be the first bottle works in the United Kingdom to make bottles solely by machinery. Their premises covered 5 acres and they employed 700 people. It became a public company in 1919 and traded as Forsters Glass Company.

After the death of John Forster in 1927, his sons assumed control. The business was later absorbed into Rockware Glass in 1968 and Rockware relocated out of St Helens in 1981.

G

Gerard Family

This family were the lords of the manor of Windle and Hardshaw and had a great influence on the town. Their direct male line can be traced to Otho, an English baron in the reign of Edward the Confessor, and their history includes five members prominent in the Counter-Reformation, one of whom was beatified and another canonised. They acquired Windle when the de Burnhill family, who held Windle, married into the Gerard family and took the land and titles.

An early heir was Sir Thomas Gerard, who was knighted in 1393 and fought during the Scottish wars and, as a knight, served in Parliament for Lancashire. His son, grandson and great-grandson were all called Thomas. The last Sir Thomas Gerard of the senior line was knighted in 1428 and conducted the Siege of Montereau in 1437, dying in 1440 without an heir. In 1435, he constructed Windleshaw Abbey. It was another Sir Thomas Gerard (c. 1520–1601) who became High Sherriff of Lancashire and an MP twice. Despite this he was sent to the Tower of London, twice accused of trying to rescue Mary, Queen of Scots. His son, another Thomas (1560–1621), was created 1st Baronet of Bryn in 1611 by James I. The Gerard family, under Sir William Gerard, took the side of Charles I and the Royalists during the English Civil War and their estates were sequestered by Parliament. Throughout the years, through marriage, they increased their estates throughout the country, including land in Kent, Lincolnshire and London.

They lived at Bryn Hall until 1750 when they moved to the Old Hall, Garswood, until 1788 when they moved to Garswood New Hall. It was at this time that most of their money was coming from coal dug up from their land, and this success was aided by the Sanky Canal. Sir Thomas Gerard (1723–80) oversaw this area and had a horse railway built to connect Garswood to a canal wharf in Blackbrook.

During the First World War, Garswood Hall was turned into a VAD (Voluntary Aid Detachment) hospital by Mary, Lady Gerard, the widow of the 2nd Baron, but she died on 23 February 1918. The family then moved to Herefordshire in 1921 and the hall was demolished. During the Second World War American troops were stationed in the grounds, which by then had become a golf course. Now the M6 goes through the grounds.

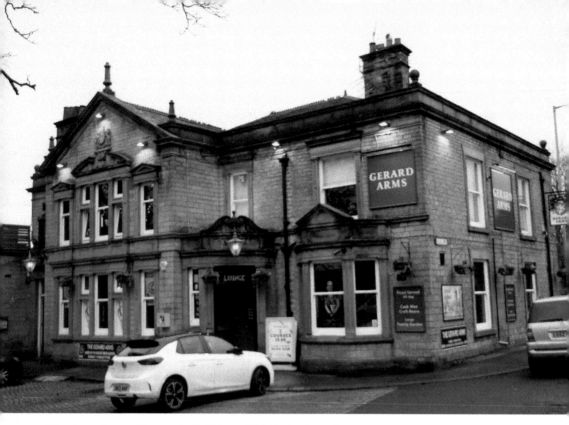

The Gerard name lives on in St Helens. This is the Gerard Arms.

The name still lives on with Gerard's Bridge, the Gerard Arms pub and many other references exist in the town.

Gladstone, William Ewart

Liverpool-born Gladstone (1809–98) served as British prime minister for four terms over twelve years, between 1868 and 1894, and had also served as Chancellor of the Exchequer.

He was also a visitor to St Helens and the most memorable occasion was when, as Liberal Party leader, he gave a speech at the Volunteer Hall, Mill Street, at the height of the 1868 election. After arriving by train the twenty-strong convoy of horse-drawn carriages made their way to the hall via Church Street, Baldwin Street and passed the Sefton Arms.

In those times potential candidates were allowed to stand for two constituencies. Gladstone's were Greenwich, which he won, and South West Lancashire, which included St Helens. He stood for the South Lancashire constituency in 1865, which had now been broken up, and failed to win, and he was to do so again in this election. However, he re-entered Parliament, and the history books, by winning Greenwich.

St Helens has a Gladstone Street, as does the Big Dam area in New Zealand, named by St Helens-born fellow Liberal Richard Seddon, who was to become the longest-serving prime minister of New Zealand.

Mill Street Barracks.

Greenall Family

The Greenall family were a leading North West brewery family. When Thomas Greenall, who was born in 1733, married Mary Turton he entered into the brewing industry. When his father-in-law died, he took over his Parr brewery and in 1762 they moved to the Hardshaw Street Brewery, which operated until 1975. Thomas's sons Edward, William and Peter joined in the business. Thomas Greenall went into a separate partnership with William Orrett and Thomas Lyon in 1788 to purchase the Saracen's Head Brewery in nearby Wilderspool, Warrington. It was so successful that within three years an expansion had been undertaken whereby they bought their own pubs and inns. And since in the 1800s it was normal for these 'tied' establishments to buy their supplies from the owners, it became a great source of income.

In 1805, Thomas Greenall and William Orrett died. In 1818, Thomas Lyon and William and Peter Greenhall had died, leaving sixty-year-old Edward to operate the successful St Helens Brewery. Edward appointed his eldest son, Thomas, as manager of their half share at Wilderspool and his other son, Peter, to run St Helens. Peter had a successful political career and Thomas became a leading brewer. Both brothers died in the late 1840s and their younger brother, Gilbert, a Parliamentarian, inherited

the breweries. His nephew, John Whitley, managed the Wilderspool brewery while he expanded the St Helens site. In 1859, long-term silent partner Thomas Lyon died and Gilbert bought his holdings, making them sole owners of both breweries. The company became Greenall & Company; later Gilbert would merge both breweries, creating Greenall Whitley & Company Limited. In 1882, Greenall's annual sales volume was nearly 90,000 barrels of beer and they owned 200 pubs.

When Gilbert and Peter Whitley died, Gilbert's son, also Gilbert, took over at the age of twenty-seven. He faced great challenges, such as motorised delivery vehicles and the First World War, but overcame them both. Between the wars they acquired further pubs, including nine in 1919, and diversified into wine and liqueurs.

Gilbert died in 1938, passing leadership of Greenall Whitley to his son Edward, who served for nine years before retiring because of ill health. He was succeeded by John D. Whitley, the first non-Greenall to lead the company in 186 years. By 1961, the company boasted more than 1,200 pubs and had a hotel division. They sponsored regional darts, fishing and racing tournaments to keep their name in the public eye.

In 1967, chairman John D. Whitley died at the age of fifty-six and was succeeded by Clarence Hughes Moors, who died after an accident in 1969. Edward Greenall took chairmanship for two years before handing it to his attorney, Christopher J. B. Hatton. In the 1970s all brewing operations closed apart from Warrington, which ceased brewing in 1991 when Greenalls concentrated on running pubs and hotels and was renamed the Greenalls Group with Peter Greenall in charge.

The Greenall sign outside the Hardshaw Centre.

Greenall, Peter

Peter Greenall (1796–1845) was the grandson of Greenall Brewery founder Thomas Greenall and played a large part in the development of St Helens. When he was twenty-one his father Edward sent him from Warrington to St Helens to look after the brewery there. In 1824, in connection with this role, he was responsible for laying water pipes from the brewery's pond to the four main streets and the Moorflat area, and for charging the residents 10s and sixpence or more rent a year. In the same year he established the St Helens Building Society – the first in the town. He was treasurer of the successor to this, which opened in 1836.

He was head of the newly formed Odd Fellow Lodge in 1825, an inaugural shareholder in the St Helens Gas and Light Company in 1832 and was a leading force in local railway development through the creation of the St Helens & Runcorn Gap Railway.

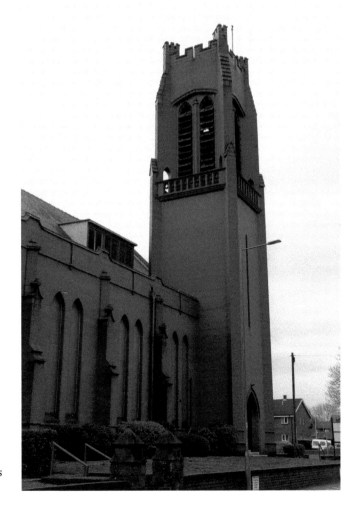

St Thomas' Church, Westfield Street, an example of Peter Greenall's generosity.

In 1921, when he married Eleanor Pilkington, the second daughter of Dr Pilkington, Greenall became connected to the town's glass industry, and the merging of the two families proved a highly effective industrial partnership.

Peter Greenall played an active role in politics and although he failed to be elected MP for Wigan in the 1837 general election, he was successful in 1841. He secured passage for the St Helens Waterworks Bill in 1844 and the St Helens Improvement Bill in 1845, which resulted in the town's first effective local government. St Helens Town Hall, which opened in 1839, was mostly the result his vision and work; he contributed £300 to the building fund. St Thomas's Church, Westfield Street, created to cater for the growing population of Greenbank, was built at the same time – again, as a result of his generosity. The Town Hall was opened on 8 October 1839 and the church was consecrated on the same day.

Peter Greenall died of a stroke at his St Helens home on 18 September 1845, at the age of forty-nine.

Haydock

Haydock is a village that lies within St Helens. Its name means 'barley, wheat' with a suffix meaning 'place', which may reflect its origins as a farming area before it was changed by collieries and the modern transport age. Locally the village is known as 'Yick' and its residents as 'Yickers'.

In 1866, Haydock ceased to be a township within Winwick parish and became a civil parish with links to Warrington, falling under their Poor Law union in the nineteenth century. In 1894, it became an urban district but lay within the Newton

Christ Church, Haydock, one of the tallest buildings to be found there.

Parliamentary constituency from 1830 to 1983 when it became part of the St Helens North constituency.

Areas within Haydock included part of Blackbrook, Old Boston and part of Haydock Park, all of which were to be transformed by the Industrial Revolution, which saw the village become one of Lancashire's richest areas for coal. For instance, Haydock Collieries, owned by the Evans family, operated thirteen collieries working at one time. Wood Pit, which closed in 1971, was the last colliery here.

In 1861, the Haydock Brass Band was formed from Lord Gerard's Hussars Band who had served in the Boer War (1899–1900). This band still plays regularly at the Haydock Park Jockey Club and have been both North West Area Champions and Butlins Champions. They have also appeared in *Brassed Off* at various theatres.

Haydock Male Voice Choir began on 1 March 1923 when a letter was circulated throughout the mining community proposing the creation of a choir. Four days later this had led to a meeting at Haydock Conservative Club. Twenty-one men attended and the choir was born, consisting mainly of office workers from Richard Evans & Co. Ltd.

The Second World War interrupted the choir's activity, but they were able to meet again in April 1944. However, since then they have continued without a break, making them one of the oldest choirs in the North West. In 1974, they recorded their first LP, *Haydock Sings*, which sold more than 2,300 copies.

Haydock Cottage Hospital

The origins of Haydock Cottage Hospital can indirectly be traced back to Richard Evans & Co., colliery owners who were recognised as enlightened employers, and Dr Thomas Ernest Hayward, who came to Haydock in 1880. He was a part-time colliery surgeon who could practise in the district.

The area had suffered the tragic Queen Pit disasters of 1868, when twenty-six miners died, and 1869, when fifty-seven died, followed by the Wood Pit explosion in 1878, which killed 200 mine workers. These disasters illustrated the need for medical care.

Dr Hayward was born in Tewkesbury in 1855 and married Catherine, who was a nurse. One night they had to attend a miner at his home after he had been run over by a colliery locomotive. After carrying out a leg amputation that saved the man's life they realised the urgent need for a hospital here, as such accidents were regular happenings.

They rented a cottage at No. 266 Church Road and created a hospital there with four beds, a room for a resident nurse, Miss Laura Wilson, and a kitchen. This opened in 1883 and Mrs Josiah Evans contributed £100 towards the maintenance for the first year, and in the second year Miss Kate Evans gave £100.

However, expansion was needed, and on 11 May 1885 a meeting was held at Dr Hayward's home at No. 22 Church Road to discuss building a cottage hospital.

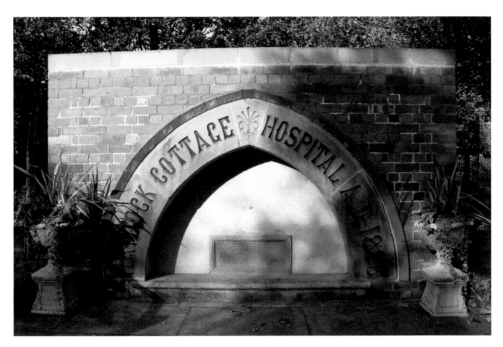

The site of the former Haydock Cottage Hospital.

Among the donors was Mrs Evans, who gave £500 from her private money under the condition the hospital was built within two years. Mr Evans also gave £500 in 'bricks and mortar', and Lord Newton donated the land. The hospital opened in July 1887 at an estimated cost of £958. The hospital continued to expand to treat injured miners and others in the industry.

Dr Hayward died in 1906 at Clipsley Lodge of 'an acute attack of laryngitis' and Catherine died in London on 27 September 1927. They are buried together in Wargrave Cemetery.

In 1930, the hospital was opened to all Haydock residents. It was closed in 1975 and demolished in 2016.

Haydock Park Racecourse

Today Haydock Park Racecourse is a leading racing venue in the country. It is situated in Newton-le-Willows, midway between Manchester and Liverpool, and dates back to the grand racecourse at Newton Common, which even had its own railway station. Racing took place here from at least 1678 until it moved to the Haydock Park site in 1899. Every July the Old Newton Cup Race, a flat handicap horse event, takes place to keep this part of history alive.

The Newton Races started in 1752 and, apart from a break around the 1820s, continued until 1898. Initially, they involved Newton Hunt members and for some

years took place on a common called Golborne Heath and were opened to anyone. Today it is owned and operated by the Jockey Club and hosts events such as the Grand National Trials in February. There is racing on thirty-two days a year combining Flat and Jump Racing.

In the 1990s, Haydock Park Racecourse was the venue for Noel Edmonds' Mr Blobby Crinkly Bottom Day, which was televised for the BBC. It also hosts pop concerts with artists such as Simply Red, Tom Jones and Rick Astley, who is from Newton-le-Willows.

Hutchinson, John

John Hutchinson (1825–65) was a chemist and industrialist who revolutionised the chemical industry and became known as the 'Father of Widnes'. However, Liverpool-born Hutchinson began his career in St Helens where he became manager at Kurtz Alkali Works, which was owned by Andrew George Kurtz whom he met when they were both studying in Paris.

In 1847, at the age of twenty-two, he moved to Widnes Dock where he established the first chemical factory in Widnes, now Cheshire. In this factory he manufactured alkali by the Leblanc process. Much of this factory's success was due to a foundry man from St Helens called Thomas Robinson, who was able to provide the huge cast-iron pots that were so important to the chemical industry.

Thomas Robinson was an orphan who was brought up by his uncle, John Cook, a butcher, and served his engineering apprenticeship with another, Matthew Johnson, at Sandbach. After working at various foundries in St Helens in 1841 he set up his own business in Bridge Street with financial help from John Cook. It was here that one of his many progressive developments was created, an improved way of making caustic pots, salt cake pans and other vessels for the alkali trades that came to the attention of Hutchinson. Thomas Robinson was eventually to concentrate on Widnes, leaving the St Helens Foundry to be managed by John Cook's sons, Joseph and Thomas.

Hutchinson opened a second alkali factory in 1859 and through several collaborations and partnerships was to revolutionise the chemical industry. He died of TB in 1865, at the age of forty.

I

Irish Community

St Helens, like many growing industrial areas, experienced a large surge in Irish immigrants in the 1840s, who came in search of work and to escape famine. Most arrived at Liverpool and, if no work could be found, walked to other destinations such as St Helens.

In 1841, there were three main Irish settlements: Greenbank with 650, Smithy Brow-Parr Street with 350 and Gerard's Bridge with 60.

This influx caused problems within the town at many levels. Many Irish would work for lower wages than the local workforce and it was feared that this would drive down wages. There was also the question of religion, as illustrated by an incident in 1838: the Protestants of St Helens walked towards the Greenbank area but as they were celebrating the anniversary of the Battle of the Boyne, stones were thrown and fighting ensued. However, their contribution to the local workforce and industry meant that the town continued to grow.

Greenbank today.

Isolation Hospitals

St Helens expanded rapidly because of its excellent transport links and increasing industrial strength, and was not a healthy place to live in the nineteenth century. As early as 1819, when the town was still small, diseases such as typhus and possibly typhoid were prevalent.

The town had poor housing and sanitation, and polluted air took its toll. As such, the area suffered two cholera epidemics in 1849 and 1854 in spite of the St Helens Improvement Bill being passed in 1845. There were smaller outbreaks of the disease too for example, in October 1866 two cases broke out in two Peasley Cross houses. Cholera was so feared that it was known as 'King Cholera'.

Other diseases also visited the town, such scarlatina, scarlet fever and even smallpox. Initially, infectious patients were sent to Whiston Workhouse, but by the mid-1870s this was overcrowded, so St Helens Corporation decided to build an infectious disease hospital.

It was opened in 1881 on Marshalls Cross Road and was known as the Borough Sanatorium, Fever Hospital or Isolation Hospital. As payment was required the hospital was not that busy, but when poor people could apply to have their fees remitted patient numbers grew to seventy-eight patients in 1890. From 1891 nearly all treatment was free.

Smallpox was also an issue and there was a bad outbreak in Peasley Cross in January 1893, with twenty-two cases also reported the following year. The levels of infection continued to rise, and the hospital was extended and new areas opened in 1897.

Haydock was another area that had an isolation area – at the Old Whint Hospital, which was sometimes known as 'Fever Hospital'. Kelly's 1914 directory states: 'St Helens County Borough (Old Whint) Smallpox Hospital was erected in 1893 and enlarged in 1903 at a cost of £750 and will hold 750 patients.'

In 1903, the hospital received 232 smallpox cases from St Helens and two from Haydock. The hospital closed in 1931, although during the First World War it could have been used as a TB hospital.

J

Jubilee Cone House

This building is part of the World of Glass and linked by a bridge over the Sankey Canal. It houses a brick-built glassmaking factory known as a 'tank house' with a ventilation cone and has the remains of a Siemens regenerative tank furnace.

It was constructed by Pilkington, glassmakers, in 1889 and represents a massive change in glassmaking processes: the Siemans furnace glass was melted in a brick-lined tank, continuously fed with material and drawn off as required. The process also allowed the reuse of the heat used in the melt, which saved fuel. The structure is around 23 metres by 11 metres and is 8 metres tall. Inside the brick cone are steel girders, supported by cast-iron pillars. This eastern chamber is the only survivor of that age as the western side was modified for later use as storerooms.

The Jubilee Cone House.

Tunnels have been exposed on the south side, through which coal gas was brought from the supplier to the furnace. Next door are coal mine pithead remains with a cage shaft that were in use before the Pilkington works were built. The tank house was closed in 1920 and is a Grade II listed building.

The section of the Sankey Canal here is known as 'the Hotties' as hot water from the glassmaking process used to come into the canal and raise the temperature. People used to swim here and it was even said that tropical fish could be found here, that is until the glassworks turned off the hot water for a while for maintenance and as the water cooled the fish died.

Junctions

St Helens played a pivotal role in railway development and became a key place in the Railway Age. This is evidenced by some of the railway junctions found here.

Earlestown Junction, on the Liverpool to Manchester line, opened in 1830 and the surviving buildings date back to around 1835. Two early railways had a point of intersection here and this was the first steam railway junction; at this point it was called Newton Junction. Five platforms form a triangular track layout, which is the oldest junction in the world between two passenger railways. One of the oldest station buildings in the world is the waiting room on the Liverpool-bound platform.

Sutton and its Junction starts its railway history with the Rainhill Trials of 1829, which took place on a 2-mile level stretch between Rainhill and Sutton. As a result

Earlestown Junction station.

of winning with *Rocket*, George Stephenson and his son Robert won the contract to build the Liverpool to Manchester line. In September 1830 the opening took place at Lea Green, and St Helens Junction opened in 1833. It houses a single-storey brick LNWR building, which dates from the 1860s. The former Junction Inn was once the stationmaster's house.

Right: Lea Green station, which reopened in 2000.

Below: Sutton Junction station.

Kurtz Family

Andreas Kurtz, known as Andrew, was a chemist who was one of the founders of the alkali trade in Britain. He was born in 1782 in Reutlingen, Germany, but at the age of thirteen he left home to escape the warring Austrian and French armies during the Revolutionary War. He went to Paris where he studied chemistry and worked in the chemical industry. When Napoleon was defeated, Kurtz went to America and became an American citizen and invented a means of manufacturing gunpowder, but he also spent time in England.

In 1816, he returned to England and leased a small chemical works on the banks of the Thames, and by 1830 he had moved to Liverpool. In 1842, against his wishes he had to take over Darcy and Dierden's alkali works at St Helens, later known as the Sutton Alkali Works, having loaned them money. However, Darcy pretended that Kurtz had been a partner who Kurtz had to challenge in court. Another court case took place in 1846 when Josias Gamble challenged Kurtz and others on an infringement of his patent on the salt cake furnace. Some of Gamble's claims were rejected; however, during the trial Kurtz died, at the age of sixty-four.

His son, Andrew George Kurtz (1824–90), was just twenty-one and studying in Paris when he took over the business. Andrew George Kurtz was very involved in the town and a benefactor of a hospital, which had just nine beds, in Peasley Cross. This was to become the Cottage Hospital and then St Helens Hospital. In 1859, he served on the committee for the local Liberal Party.

By the 1890s the Kurtz business had expanded and was one of the largest chemical plants in the area, producing soda and bleaching powder. A. G. Kurtz & Co. chemical works and other chemical companies were incorporated into the United Alkali Co. Ltd in 1891.

On 12 May 1899 an explosion and fire in the chlorate house happened on the Kurtz site, which killed five men: Frederick Faram (sixty-two), shipping clerk, Argyle Street; Thomas Duffy (thirty-five), labourer, Barber Street; Richard Swift (twenty-one) slater, Orrell Street; William Gibson (forty), labourer, Frozers Court; James Grey (sixty-four), labourer, Manor Street. It also injured many more people.

A cloud of yellow nitrate glass covered the neighbourhood and the nearby gasometer split across its top. The escaping gas was ignited, resulting in flames hundreds of feet high. The explosion rocked the town. The factory was all but destroyed, as were many houses; roofs were blown off schools and a large window was blown out of St Helens Parish Church.

The alkali works closed in 1920.

Legends

These are just two of the many legends associated with the St Helens area. The story of the Griffin (or Gryphon) of Bold tells the tale of John Houghton, the village blacksmith and the founder of the Bold family.

According to legend a griffin (a terrible, mythological creature that is part-lion, part-eagle) was terrorising the area, killing livestock. John is credited with slaying the creature and was rewarded with lands north of Farnworth.

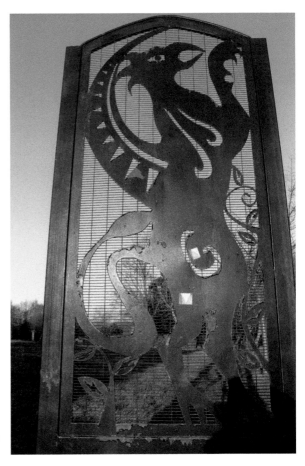

The Griffin portrayed in artwork in Standish Street.

There are two versions of this legend. The first says that John, dressed in animal skin, stood in a field where he thought the griffin would appear. The griffin seized John in his talons and carried him over the Mersey to Halton and dropped him onto the rocks. As the griffin flew down to kill him, John slew it with his sword, cut off its head and took it back to Farnworth.

The second version states that he built a metal cage and then locked himself in it so he could fight the griffin in safety. The creature took the cage to Halton rocks and tried to kill John by dropping the cage on the rocks. However, as in the previous version, it was John who slew the griffin.

As his reward John was granted all the land he could ride around in one night. This became known as the 'Lands of Bold', and John was known as John de Bold. There is an artwork in Standish Street that illustrates this legend.

The White Rabbit of Crank is another well-known legend, dating back to when James I reigned (1603–25) and fear of witches was strong. The setting is Crank where an elderly, foreign woman and her granddaughter Jenny lived. The woman was highly regarded because of her knowledge of herbal remedies, although some villagers thought she was practising witchcraft. A man called Pullen, a miserly, single man with a wasting disease, sought her help. When his condition worsened he thought he had been bewitched and was obsessed with breaking this spell. Superstition said he could only do this by 'drawing blood from the witch'. Together with a wastrel called Dick Piers, a local poacher, they broke into the old woman's cottage, dragged her out of bed and cut her arm. On hearing the commotion Jenny and her pet white rabbit went to help and ran off in fear. The men gave chase to Billinge Beacon where they killed the rabbit. Jenny's body was found the following day. Shortly afterwards Dick Piers claimed to have seen the rabbit and was so scared he decided to give himself up, but before he could he was found dead at the bottom of a local quarry, apparently having committed suicide.

Pullen continued to live in the village, but he too would die a mysterious death involving the white rabbit.

M

Melling, William

Although William Melling was born in Wigan in 1839 he moved to St Helens when he married Anne Woods of Sutton on 29 April 1863. The couple moved to Hall Street and Melling started work at Daglish's foundry as an engineer, rising to foreman. It was here he met an apprentice called Richard Seddon, who was to become New Zealand's longest-serving prime minister.

The two men became great friends and corresponded regularly, right up to Melling's death in 1905. At Christmas, Seddon would send New Zealand lamb as a gift to him. In his letters Seddon referred to Melling as 'My dear old friend' and Seddon named a suburb of Wellington 'Melling' as a tribute to his old friend, as well as the Melling Bridge, which spans the Hutt River. This happened after Seddon had revisited England and met his friend, Melling, who had said that Seddon 'were a good un'.

Hall Street, where William Melling lived.

Mill Street Barracks

In the 1850s many local men spent their spare time with the Volunteers, drilling and learning the craft of soldiering. This was to decline but because of an invasion threat in 1859 the 47th Lancashire Rifle Volunteer Corps (RVC) was formed, consisting of five companies. The Volunteers were formed by William Pilkington and other industrialists encouraged their workforce to join the movement. However, because of Pilkington's age the commander was Major David Gamble.

In 1861, he built Mill Street Barracks on the corner of Mill Street and Volunteer Street to serve as their garrison, which was to become the 21st Lancashire Rifle Volunteer Corps in 1880, with a rifle green uniform and scarlet facings. On 1 July 1881, it became a Volunteer Battalion, the Prince of Wales's Volunteers (South Lancashire Regiment), and in 1886 the 2nd Volunteer Battalion, South Lancashire Regiment, eventually becoming the 5th Battalion South Lancashire Regiment.

It served at Ladysmith, South Africa, in 1900 and received its first battle honour, South Africa 1900–01. In August 1914 the battalion was mobilised at the barracks before being deployed to the Western Front where they fought at the second and third battles of Ypres, the Somme, Cambrai, Defence of Givenchy and other battles.

At the outbreak of the Second World War they were still based at Mill Steet Barracks, but became the 61st (5th Battalion, the South Lancashire Regiment) Searchlight Regiment, Royal Artillery in 1940. This unit evolved to become the 612th Regiment, Royal Artillery (the South Lancashire Regiment) in 1945. During this war they served in Scapa Flow, Orkney, Liverpool during the Blitz, and the German surrender of Dunkirk.

In 1947, it became the 596th Light AA Regiment Royal Artillery (the South Lancashire Regiment) and the 436th (South Lancashire Artillery) Light Anti-Aircraft Regiment, Royal Artillery in 1955. In 1969, the presence at the barracks was a single cadre, but in 1973 this was extended to form the 213 (South Lancashire Artillery) Air Defence Battery within the 103rd Lancashire Artillery Volunteers Regiment, Royal Artillery. In 1992, the battery moved to more modern facilities at Jubilee Barracks and the Mill Street Barracks were decommissioned and converted for use by the Sea Cadets as the Training Ship Scimitar.

During both wars it was used as a morgue and has a reputation for being haunted.

The sign over Mill Street Barracks.

Newton-le-Willows

Newton-le-Willows is a historic market town, situated east of St Helens, whose original name was Newton-in-Makerfield. Newton means 'new town', while Makerfield derives from the ancient Brittonic word *mager* meaning 'wall' and the English word 'field'. In the Domesday Book 1086 it is referred to as 'Neweton' and recorded as having twenty-two households, with Roger of Poitou as tenant-in-chief and lord of the manor. The previous lord had been Edward the Confessor, who died in 1066. Makerfield was added later and was recorded as 'Makeresfeld' in 1205 and 1351, as 'Makefeld' in 1206, 'Makerefeld' in 1213 and 'Makerfield' since 1242. Newton

Newton-le-Willows High Street.

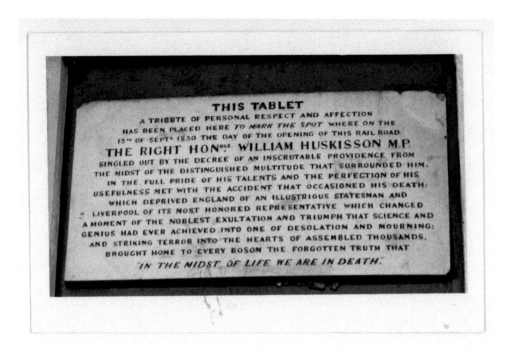

Huskisson Memorial.

was head of a hundred before the Norman Conquest and afterwards became part of West Derby hundred.

On 19 August 1648, the Battle of Winwick Pass, or Red Bank, took place and was one of the last major battles of the Second English Civil War. Winwick Pass lies between Newton and Winwick and, after the joint Northern Royalist and Scottish Engager army were defeated at Preston, was thought suitable to defend by their commander, the Duke of Hamilton. While the Scottish infantry, commanded by Lieutenant General William Baillie, stayed Hamilton and the cavalry went to Warrington. When the Parliamentarian army, commanded by Oliver Cromwell, arrived on Saturday 19 August 1648 the six-hour battle began. It ended in defeat for the Scots and around 1,600 men died. The name 'Red Bank' is thought to come from the amount of blood spilt there.

Newton railway station, which opened in 1830, is on the Liverpool to Manchester line and is one of the oldest in the country. Parkside station, which opened in 1830 and closed in 1878, is notable as the place where the world's first railway death occurred. Liverpool MP William Huskisson was killed on the opening of the Liverpool to Manchester line. Newton was home to Parkside Colliery from 1957 to 1993, and also the Newton Races.

Newton became part of St Helens Metropolitan Borough Council in 1974 as part of local government reorganisation.

Nightingale, Florence

Nurse Florence Nightingale, who was born in Florence in 1820, is known as a woman who transformed patients' medical care. After returning from the Crimean War she took an interest in British hospitals, including some in St Helens. Catherine Hayward, wife of Dr Hayward, founder of Haydock Cottage Hospital, was one of the first nurses to train under Florence Nightingale at St Thomas's in London. The two ladies corresponded regarding the cottage hospital. In one letter Miss Nightingale said:

> I have enquired of the most competent authorities concerning your question. Burdett's Cottage Hospitals' gives plans of existing Cottage Hospitals and gives plans of some good ones. It appears to give costs of building of specified Hospitals.
>
> I am sorry to give no more specific information but would gladly answer any further questions that I could and would undertake to have your sketch plans, when prepared, carefully looked over. Success to your undertaking – excuse pencil.

An undated postcard said:

> I will very gladly try and help in the way you ask but I am more than usually overworked and ill just now. And I cannot 'recommend', tho' there are so many, any 'plans' or 'books' of 'Cottage Hospitals' on the spur of the moment I will enquire. One thing I can promise at once, that if you will send me at any time the sketch of your future Hospital, I will have them revised and carefully overhauled.

Mother Magdalene Taylor arrived in Liverpool in 1882 to found the Raven Way Hospital, George Street, which was the beginning of the Providence Hospital, and she also worked with Florence Nightingale in the Crimean War. They became good friends, but Florence would not support Mother Magdalene in her quest to found this hospital as she thought it would not succeed. Florence Nightingale died in 1910 at the age of ninety.

Nine Arches Bridge

The Nine Arches, Newton-le-Willows, also known as the Sankey Viaduct, has a unique place in the pages of history. It is where the first canal of the Industrial Revolution, which opened in 1757, is crossed by the world's first passenger railway, the Liverpool to Manchester line, which opened in 1830.

However, the railway construction posed problems for the engineer George Stephenson as the Sankey Brook Navigation Company objected to the building of the railway. They insisted that the clearance over the Sankey Canal had to be 60 feet to

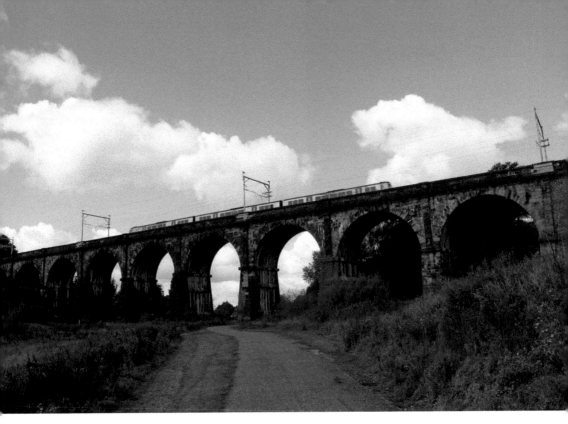

The Nine Arches Bridge.

allow canal flats to pass under with sails fully rigged. William Allcard was chosen to design the structure by Stephenson, and he presented the Nine Arches Bridge. Each arch has a 50-foot span and is built of red brick with yellow sandstone facings and cost more than £45,000. Each arch rises from the massive sandstone slabs, which were acquired locally. The height of the arch from the parapet tops to the canal water is 70 feet and the railway width is 25 feet. The approach is along an embankment mainly of clay dug out of the high ground that borders the Sankey Valley, with thousands of tons of marl and moss compacted with brushwood used to increase the height of the embankment.

There is also a nineteen-arch viaduct at Carr Mill, which served as a footpath as well as carrying the main pipe to take water from Rivington Reservoir to Prescot Reservoir.

Nuremberg Trials

The Nuremberg Trials were a series of military tribunals held following the Second World War by the Allied forces – Great Britain, the United States, Soviet Union and France – under international law and the laws of war. During the trials many leading Nazi Party members were prosecuted for war crimes. The chief prosecutor for Great Britain was Hartley William Shawcross (1902–2003), who was MP for St Helens at the time.

Shawcross was born in Germany. His father, John, was an English professor at Frankfurt University while Hilda, his mother, was a relative of politician John Bright. The family returned to England shortly after his birth. He followed his interest in politics and at sixteen joined the Labour Party and campaigned in the 1918 general election. Shawcross gained a first-class (with honours) law degree and moved to Liverpool where he was a lawyer and lectured at Liverpool University (1927–34). In the 1945 general election he won at St Helens by a large majority, becoming the town's MP. Labour prime minister, Clement Attlee, appointed Shawcross as Britain's Attorney General and it was in this role he led the British prosecution at Nuremberg. Here, among others, he successfully prosecuted Hermann Göring, Rudolf Hess, Albert Speer and their colleagues. He also prosecuted Lord Haw Haw, William Joyce, for high treason by broadcasting for Nazi Germany. Joyce was found guilty and executed on 3 January 1946. He also prosecuted traitor John Amery, 'the Acid Bath Murderer' John George Haigh and the Atom bomb spy, Klaus Fuchs.

Representing St Helens in Parliament, Shawcross promoted the Trade Disputes and Trade Unions Bill. In April 1951, Shawcross was appointed president of the Board of Trade, but lost office when Labour were defeated in the 1951 general election. He retired from the House of Commons in 1958, becoming a life peer later that year. He was a crossbencher in the House of Lords but supported the Social Democratic Party in the 1980s. He sat on the boards of various companies, including Hawker Siddeley, Shell, EMI, Times Newspapers and Thames Television. He died on 10 July 2003.

Oscar Winners

St Helens can lay claim to two Oscar winners: George Groves and Colin Welland. George Groves was born on 13 December 1901 above a barber's shop at No. 57 Duke Street. His father, George Alfred Groves, was twenty-two, a master barber who owned two barber's shops in Duke Street and Owen Street, Thatto Heath. His mother, Harriet, was twenty-five, and also living at the house was his twelve-year-old uncle William Arthur Groves. His father was an accomplished musician and founder of the first brass band in the town. His son, George, inherited his father's musical ability and became proficient in a number of instruments, playing the cornet at the Theatre Royal. As well as honing his musical ability he worked for his father as a lather boy. The family moved to No. 47 Owen Street and George was to have three siblings – Hilda (born 1903), Herman (born 1909) and Olive (born 1919).

After being educated at Nutgrove Junior School and Cowley Grammar School he gained a scholarship to Liverpool University and graduated in 1922 with an honours degree in engineering and telephony. His working life began at GEC, Coventry, before he looked to the United States for employment.

He sailed to New York on the SS *Laconia* on 1 December 1923 and began work at Bell Laboratories researching and developing film sound technology. When the Bell system was taken over by Warner Brothers he was seconded to Los Angeles where, in 1926, he worked on *Don Juan*, which starred John Barrymore. This was the first full-length film to have a synchronised sound track. He would move to Hollywood in 1927. He helped to develop sound-on-disc technology and his expertise in this field would be used in early sound films such as *The Jazz Singer*, *The Singing Fool* and *The Desert Song*.

In 1927, he worked on the soundtrack of *The Jazz Singer* with Al Jolson, who called him 'the quiet Englishman'. This was the first film with synchronised dialogue, and this marked the end of silent films and the beginning of 'talkies'.

This was the start of a successful career at Warner Brothers, which would see him win Oscars for Best Sound for *Sayonara* in 1958 with Marlon Brando and *My Fair Lady* with Audrey Hepburn in 1965 – he received this Oscar from Steve McQueen and

Claudia Cardinale. Over the course of his memorable career, he worked on thirty-two films that received Academy Award nominations for Best Sound. In 1957, he became Director of Sound at Warners and in 1972, when he retired, he was awarded the prestigious Samuel L. Warner Memorial Award by the Society of Motion Picture & Television Engineers. This was presented to him by his old boss, Jack Warner. He died in 1976 and is buried in the Forest Lawn Cemetery, Hollywood Hills.

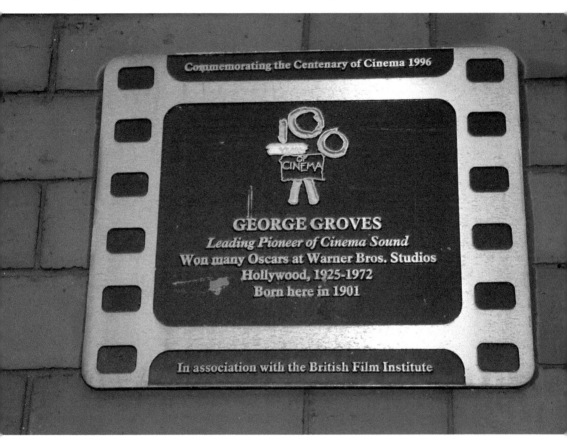

The plaque marking the birthplace of George Groves.

Parr

Parr (also known as Parre) was an original township and one owner was the Parr family. Family member William Parr was an outlaw for murder who had a small Laffak estate. His fortunes changed when he fought with John of Gaunt's army in Gascony and was pardoned. He married Elizabeth de Ros, heir to Kendal Castle, in 1382 and this is the branch from which Catherine Parr, Henry VIII's last wife, is descended. John Byrom, through marriage, inherited much of the Parr estate and established Parr Hall as the family's main seat. It was rebuilt in the 1660s and, by the 1950s, all that remained of it was one wing and a small gatehouse.

The road to Parr.

Parr Manor was purchased by Liverpool merchant William Clayton (c. 1645–1715) in the eighteenth century and passed to his daughter Sarah, who developed the Parr collieries. Sarah was to be declared bankrupt in 1778 and the younger James Orrell of Blackbrook House bought the Parr Hall estate and was to be succeeded by his daughter Elizabeth. Her legacy can still be seen in St Mary's Church, Blackbrook, which she had built in 1845. Parr Hall became a ladies' boarding school when it was leased to Mr and Mrs Morgan. Following their deaths in 1855 Miss Elizabeth Orrell was looking for a new headmistress. Sister Elizabeth Prout (1820–64), founder of the Sisters of the Cross and Passion, took charge of the school, though her work was with the children of the poor. The last residents of Parr Hall were the Tyrer family, who were to turn it into a farmhouse.

Parr was turned into an industrial hub with collieries, chemical works and ironworks to be found here at one point, but many areas have now been transformed into green spaces.

Parr, Lily

Lily Parr (1905–78) was one of the town's trailblazers and a very successful footballer. She was born, the fourth of seven children, in a rented house in Union Street, Gerard's Bridge. Her father was George, a glass labourer, and her mother was Sarah Parr. In order to make extra money the family rented out rooms in their house and space in their yard.

Her love of football began when she started playing with her brothers and then began playing with the St Helens Ladies Team at Parr. At the age of fourteen she was recruited for one of the most successful women's football teams of the time: the Dick, Kerr Ladies.

This team mainly consisted of workers from their Preston factory, which made tramcars and light railway equipment, but with the outbreak of war began making munitions. While playing for this team she lodged with teammate Alice Norris, also from St Helens. In her first season she scored forty-three goals and more than 900 goals in her career. She was a 5-foot 10-inch-tall winger who liked smoking woodbines.

During the First World War interest in women's football grew, and continued afterwards too, as illustrated by the attendance of 53,000 spectators at a 1920 Goodison Park match when Parr's side won 4-0. She was paid a weekly wage of 10s and travel expenses. The female teams played against male teams as well, and Lily played in the first women's international football tournament between England and France in London in 1920. The team also toured France and the United States. In later life Parr trained as a nurse and worked in Whittingham Mental Hospital until retirement. She died in 1978 of breast cancer and is buried in St Helens.

In 2002, she became the first woman to be inducted into the National Football Museum's Hall of Fame, and in 2019 her statue was unveiled at this museum in Manchester – the first statue to be dedicated to a female footballer in the country.

Parr, St Peter's Church

This church was built in 1844 at the top of Boardmans Lane but burnt down in the early 1860s. It was rebuilt in Broad Oak Road in the mid-1880s and consecrated in January 1886. This new church was designed by J. Medland Taylor at a cost of £2,600 to build.

The walls are a mixture of red and yellow sandstone and copper slag, and it has slate roofs. There is a nave, north and south aisles under catslide roofs, a double south transept, a timber chancel screen from around 1920, a south vestry and a north organ loft. At the south-west corner is the broach spire with a weathervane.

The two-manual pipe organ was designed by Henry Willis, an organ player who is considered to be one of the foremost organ builders of the Victorian era. He built the organ at Saint George's Hall, Windsor Castle, which was destroyed by fire in 1992.

One of the most notable people associated with the church is Revd A. A. Nunn, who ministered to the people here for forty-one years. During the cholera epidemics of 1849 and 1854, despite there being no cure, he saw all ninety victims of these epidemics before they died. In the transept there is a memorial wall to the minister, who died in 1889.

The church is within the Church of England Deanery of St Helens within the diocese of Liverpool and is a Grade II listed building.

St Peter's Church, Parr.

Pilkington Glass

One of the most well-known names in St Helens is that of the Pilkington family, who founded the international glass company. However, glassmaking in the area dates further back as an early business owned by John Leaf Sr, who died in 1713, is recorded in Sutton. The Canal Age brought the glass giant British Cast Plate Manufacturers here in 1733. The first plate glass in the country was manufactured at the Ravenhead factory at the end of the Sankey Canal; for many years this was the largest glassworks nationwide.

The former Pilkington Head Office.

The Crown Glass Works at Eccleston belonged to Mackay and West before passing to Pilkington. In 1826, the St Helens Crown Glass Company was established, with partners including Peter Greenall and William Pilkington. William Pilkington was the great-grandson of Richard Pilkington of Horwich, near Bolton, and was apprenticed to Dr William Fildes in St Helens around 1781. In April 1786, he qualified in London as a doctor and two years later returned to here where he took over the practice of Dr Fildes (who had died) in partnership with John Walker.

Pilkington married Anne Hutton and two of their thirteen children – Richard, born 1795, and William, born 1800 – were the Pilkington Brothers, who made the company a world leader. Sir William Pilkington was an apothecary and had a shop that sold wines and spirits. After retirement from medicine in 1813 he still maintained the shop. His two sons joined him and it became William Pilkington & Sons. They were so successful they began to rectify and compound the spirits themselves, and built a successful plant at the junction of Bridge Street and Church Street in 1823.

Continental advances in glassmaking were adopted by the company, such as when Pilkington started to make German sheet glass in 1841. At the end of the nineteenth century bottle, plate and crown glass were manufactured. In 1845, they became known as Pilkington Brothers and in 1894 they became Pilkington Brothers Limited. From 1953 to 1957, Sir Alastair Pilkington and his team invented the float glass process, which revolutionised glass production worldwide. The new Pilkington head offices were completed in 1964. Today the business is called Pilkington Group Limited and is a subsidiary of the Japan-based NSG group.

Princess Sapieha

Princess Sapieha was born Mary Bold on 4 August 1795 and was the daughter of Peter Patten Bold and his wife Mary of Bold Hall. She had one sister, Dorothea; however, as the eldest, when her father died in 1819 she inherited his halls and estate.

Shortly afterwards she met her future husband, Prince Eustace Sapieha, from the duchy of Lithuania. In December 1822, they married at Bold Chapel, although she was already suffering from tuberculosis. They lived at new Bold Hall until her death from this disease in Rome on 16 December 1824. She is buried in St Luke's Church, Farnworth, and there is a monument to the princess there, which was created by Pietro Tererani.

Quaker House

The Quaker House, sometimes known as the Friends' Meeting House, is the town's oldest building. It was standing in 1597 when three plots of land were recorded as being sold by Sir Thomas Gerard of Bryn. The building and three land plots were later bought by Quaker George Shaw, a farmer and saddler from Bickerstaffe, in 1676. The Church Street site opened as a place of worship in 1679 and has been a meeting place for Quakers ever since. Shaw Street, George Street and Bickerstaffe Street were all named after the man who founded the Friends Meeting House. The Friends' Gardens is to the east and was once a burial ground, and by the south wall there are three flat gravestones. There is also an Ice Age stone, which was transported from Crab Street and was another of George Shaw's properties. The garden is now leased to the town and managed as a public park.

The sundial over the door of the house has the date '1753' inscribed upon it. The first reference to the sundial dates back to 1691 when it was 'agreed that a sundyall

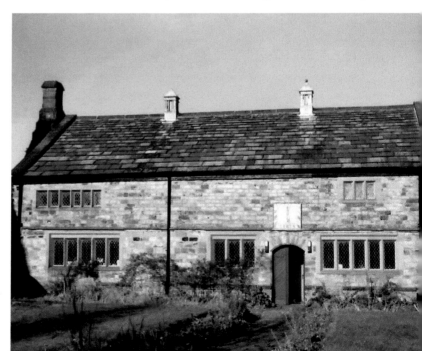

The Quaker House.

The Friends Garden.

be set upon the meeting house wall which Alexander Chorley is decided to prepare and give us account of the charge'. Further records show that the stone was left with Alexander Chorley to make the sundial. However, no further mention is made of it. Alexander Chorley died in 1709 and in his will he left mathematical instruments and books, which were rare possessions at that time. The sundial does not face south, but was correctly marked out to give the true time by the sun.

Queen Victoria Statue

The statue of Queen Victoria has ruled over Victoria Square since 1905. It now stands on the western side of the square after being renovated and relocated in 2000. It was built following Queen Victoria's death in January 1901. It was given to the town by Colonel William Pilkington, who was mayor of St Helens in 1902 when the coronation of Edward VII took place. He wanted to recognise the benefits the town had received in the queen's reign, including the borough charter in 1868 that created the town of St Helens.

Colonel Pilkington, a member of the glassmaking company, commissioned George Frampton to create the statue. Frampton was no stranger to this area of sculpture as he had already created a statue in Kolkata (formerly Calcutta) and he used the same mould for casting statues in Leeds and Winnipeg, Canada. Liverpool company Briggs & Wolstenholme were the architects, and it was built by W. Thornton & Son – also of Liverpool.

The bronze figure is on a granite base and a sandstone pedestal. It stands around 3.2 metres (10.5 feet) high and the base and pedestal together are around 3.4 metres (11.2 feet) in height. Queen Victoria sits on a throne with the sceptre resting on her right forearm and holding an orb in her left hand, decorated with a rose to represent Lancashire. The queen is wearing a brocade dress with a sash and a cloak. Her feet are resting on a cushion, while behind her head is a laurel wreath with a halo-like appearance. The back of the throne has a statue of St George in armour, representing England.

On the pedestal is a bronze plaque inscribed: 'VICTORIA 1837–1901' and on the base is a plaque that reads, 'ERECTED BY COLONEL W.W. PILKINGTON.VD., J.P. 1906.' It is Grade II listed.

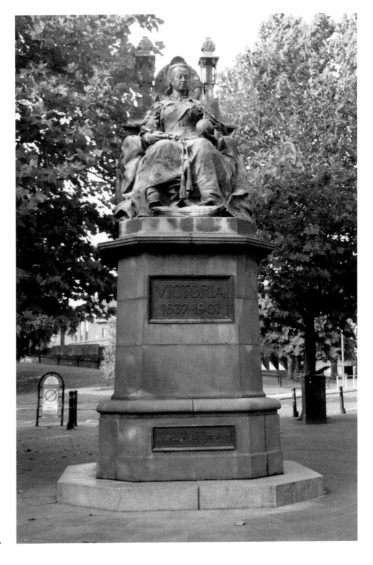

Queen Victoria's statue.

Rainford

This is a historic village that dates back to 1189 and became part of St Helens metropolitan borough in 1974. It was the home to industries such as making clay smoking pipes until 1956 and Rainford Potteries (1890), who made earthenware drainpipes. There was coal mining until the late 1930s and sand excavation for the glass industry until the mid-1960s.

Farming is also a mainstay of the village, with arable and livestock farming being abundant here. Victoria Farm, according to one former resident, Annie Harrison, had around 70 acres and was part of Lord Derby's Knowsley estate, situated by Rainford Junction.

As St Helens grew, so did Rainford. House prices in Rainford appreciated because of the increased business the Sankey Canal brought, and the Rainford railway line

Above and opposite above: The plaque at All Saints' Church, Rainford.

Rainford Junction.

opened on 1 February 1858. However, the atrial engine did not travel over the newly laid track to Gillar's Green Colliery, Eccleston, until March 1859. Rainford Junction takes its name from the fact it contained the junction between the Bury Railway's Skelmersdale Branch and St Helens Railway.

Rainford holds many traditional events, such as Rainford Walking Day and Rainford Town Show. There are three smaller villages that are near to Rainford: King's Moss to the east, Crawford to the north-east and Crank to the south-east. Crank is well known for Crank Caverns and the legend of the white rabbit.

Rainhill

Rainhill became part of wider St Helens in 1974, but historically was part of Lancashire and within the parish of Prescot, part of the hundred of West Derby; after 1894 it was part of Whiston rural district. It played an important role in the development of the railways when the Rainhill Trials were held here in 1829.

Rainhill was first noted in Norman times, but its name is thought to derive from the Old English name of 'Regna' or 'Regan'. It was known as 'Reynhull' in 1256 and 'Raynhull' in 1285. It is thought the village was divided into two in 1246 following Roger of Rainhill's death when a portion was left to each daughter – one was Rainhill Stoops and the other was around Rainhill Hall, off Blundell's Lane.

An early entrepreneur was Bartholomew Bretherton, who together with his brothers Joseph, Francis and Peter came here from Stonyhurst to find success in Liverpool. In 1800, Bartholomew founded a coaching business, and by 1820 he had most of Liverpool's coaching operations. His coaches were operating to and from Manchester fourteen times daily, and Rainhill was the first stage. New facilities were developed alongside the Ship Inn, originally the New Inn, built by Henry Parr in 1780. It is believed there was stabling for around 240 horses, farriers, coachbuilders and veterinaries.

Bartholomew bought land in Rainhill, including, in 1824, the manor of Rainhill. He also built Rainhill House, which became Loyola Hall between 1923 and 2014, a retreat centre run by the Society of Jesus. Since 2017 it has been known as Rainhill Hall and is a wedding venue. Bretherton also built the Roman Catholic St Bartholomew's Church, Warrington Road, in 1838–40. Art historian Nicholas Pevsner said it was 'the noblest catholic church in South Lancashire'. It is a Grade II listed building. A Wesleyan Methodist Church was built in 1858 and while the Congregationalists started preaching at the Holt in 1828, it was 1857 before a mission room was built. In 1891, a stone church was built by Miss Ruth Evans as a form of memorial.

Among the other businesses to be found here were file and tool making, parts for watchmaking and a brass foundry.

Mass murderer Frederick Deeming resided at Dinham Villa, Lawton Road, where in 1892 the bodies of a woman and her four children were found. However, Deeming had married Emily Mather at St Ann's Church, Rainhill, and they had emigrated to

Above: The former St Ann's School, Rainhill, which dates back to 1840.

Below: St Bartholomew's Church, Rainhill.

Melbourne, Australia, where Deeming was to murder her. Deeming was convicted of the murder of Emily Mather and hanged in Melbourne Old Gaol, while Dinham Villa was demolished in April 1892. The Rainhill victims – Deeming's first wife, Marie, and their children Bertha (ten), Mary (seven), Sidney (five) and Leala (eighteen months) – were interred at St Ann's Church's graveyard, but since the headstone marking their grave was stolen their graves are unmarked. By contrast, in the Church of England graveyard in Melbourne where Emily Mather was finally laid to rest in 1892 there is a monument to her paid for by public subscription. Many people think that Deeming was also Jack the Ripper.

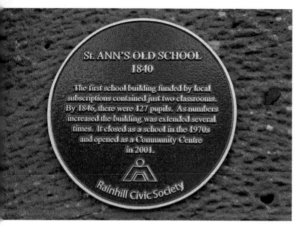

Left: The plaque at St Ann's School, Rainhill.

Below: St Ann's Church, Rainhill.

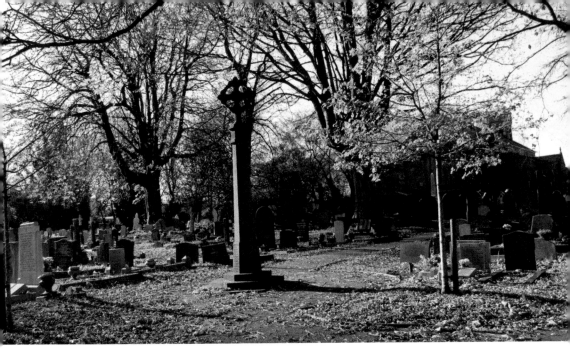

St Ann's graveyard, where the Rainhill victims of Frederick Deeming are buried.

Rainhill Hospital

Rainhill Hospital began life as the third Lancashire County Asylum when it opened on 1 January 1851. The principal architects were Harvey Lonsdale Elmes and George Enoch Grayson. County asylums go back to 1808, when the County Asylum Act was passed; it allowed counties to levy a rate in order to fund the building of county asylums. The intention was to remove the 'insane' from workhouses and provide them with a better care system. However, due to the Act's deficiencies only twenty were built nationwide. Following the County Asylum/Lunacy Act in 1845 more were built, as by law counties had to provide 'Asylum for their Lunatics'. Inside the asylum men and women were segregated and wards could house up to fifty people.

Rainhill Hospital was the Lancashire County Asylum until 1861 when it became the County Lunatic Asylum until 1923. From 1923 until around 1948 it was the County Mental Hospital and then it became Rainhill Mental Hospital. In the early 1900s it had more than 3,000 patients and was said to be the largest mental health asylum in Europe. In December 1911 it housed 1,990 patients. During the First World War, there were 2,395 patients. A total of 110 staff had been called up, with four out of six medical staff joining the RAMC (Royal Army Medical Corps). During the first nine months of 1918 there were nearly 500 deaths, 119 from tuberculosis and the remainder from the Spanish flu epidemic.

Of all Rainhill Hospital's medical centres the most notable is probably the Scott Clinic, which housed Michael Abram after he was convicted of stabbing Beatles member George Harrison.

Rainhill Hospital was demolished in 1991 and is now a housing estate and the Reeve Retirement Village.

Above: Rainhill village.

Below: Reeve Retirement Village.

Rainhill Trails

These trials took place in October 1829 in Rainhill and helped to put the village on the global map as it marked the start of the Railway Age. The trials were to find the fastest and most reliable steam engine, and the Liverpool & Manchester Railway Company directors offered a £500 prize. This would go to the locomotive that could transport a considerable load at least 10 miles per hour over a distance of 70 miles.

Initially there were ten competitors who put forward their names during summer 1829, but only five arrived at Rainhill in time for the start. The Cycloped, a horse-powered platform, and Perseverance, an adapted engine for a road-going steam coach, were not really competitors. The race was between the *Novelty, Sans Pareil* and *Rocket*.

Rocket won and reached speeds in excess of 30 miles per hour and completed all the requirements. *Rocket* had been entered by Henry Booth, treasurer of the Liverpool and Manchester Railway, and George Stephenson, their engineer. The steam engine was designed by George's son Robert and built at his company works at Newcastle-upon-Tyne. Father and son received the contract for the new railway and there was a ceremonial opening of the new line and station at Lea Green in September 1830. Sutton's main station was St Helens Junction, which was opened in 1833.

The George Stephenson Skew Bridge.

Another connection between Stephenson and Rainhill is the George Stephenson Skew Bridge, an arched sandstone bridge that carries the main road over the railway, so called from the unusual, diagonal, thirty-four-degree angle to the railway that passes under the bridge. Construction began in 1828 using stone blocks, some as heavy as 2 tons, which were cut, dressed and numbered in advance to ensure they went into the right place. There is an inscription carved below the parapet on the eastern side which states the completion date as 'June 1829'. It is the world's first bridge to cross over a railway at an angle and has a milestone noting the distances

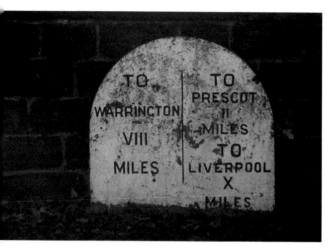

Left: The milestone on the Skew Bridge.

Below: The former British Railways Mk I carriage, which houses the Locomotive Trials exhibition.

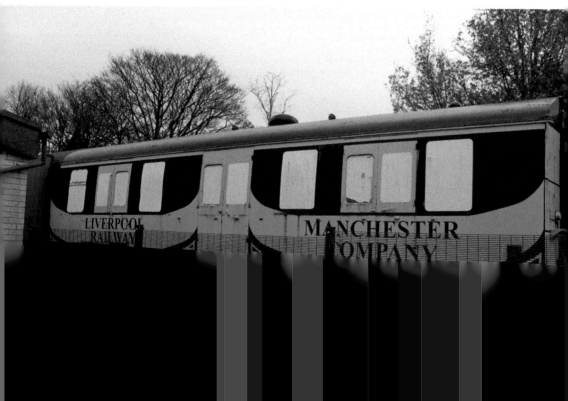

to Warrington, Prescot and Liverpool. The bridge was widened to accommodate an increase in traffic. It is a Grade II listed structure.

Rainhill station and Skew Bridge are still celebrated as the site of the locomotive trials, with an exhibition in a former British Railways Mk I carriage in the grounds of Rainhill Library, View Road. The exhibition has extracts from the trials accounts, including drawings and sketches and contemporary views of the railway at the time of its opening. There are scale models, dioramas, print reproductions of early locomotives, original relics, scenes from Liverpool & Manchester Railway, photographs of the Steam Cavalcade during the Rocket 150 celebrations of 1980 and of how the carriage was transported to Rainhill.

Robey, Isabel

Isabel Robey was born and lived in the Windle township. On 19 August 1612, at Lancaster Castle, she was tried as a witch with the famed Lancashire Witches, although she did not know them.

Isabel was unfortunate that she lived during the reign of James I (1603–25), who firmly believed in the existence of witchcraft. In 1597, the king wrote his book on witchcraft, *Daemonologie*, which was reprinted in 1603. He repealed the Elizabethan Witchcraft Act and in 1604 replaced it with a harsher act, which stated the punishment for witchcraft was death.

Little is known about Isabel, but her trial record was documented by Thomas Potts of London, clerk of the court. His trial records were published in 1613 as *The Wonderfull Discoverie of Witches in the Countie of Lancaster*.

Isabel's journey to Lancaster began on 12 July 1612 when her accusers were examined before Sir Thomas Gerard on events occurring between 1608 and 1612. The chief accuser was Peter Chaddock, her goddaughter's husband, of whom Isabel strongly disapproved. Today it would be seen as a family feud, but then it could be a matter of life and death. Her other accusers, her neighbours, were Jane Wilkinson, Margaret Lyon and Margaret Parre, who were also examined on that date. Their evidence sent Isabel to her death at Lancaster Castle.

Unbelievably, prisoners were not allowed to have a defence council to plead for them, nor could they call any witnesses to vouch for them. The jury 'upon their oaths found the said Isabel Robey guiltie of the Fellonie by Witch-craft', and although no murder or death had occurred, the death sentence was passed.

Isabel Robey was hanged on 20 August 1612. The repeal of the Witchcraft Act only took place in 1951.

St Helens Rugby Football Club

This well-known rugby league club was founded on 19 November 1873 at the Fleece Hotel on Church Street by William Douglas Herman. Herman was the newly appointed head chemist at Pilkington's Crown Glass Works, and had played rugby at his school, college and for the Crescent Club, London, where he was born. He was disappointed that there was no rugby club in the area but discovered that there was enthusiasm for this new game, and by 1872 clubs had been formed in Liverpool, Manchester and Wigan. He wanted St Helens to have a club and after failing to engage his work colleagues he placed an advertisement in the *St Helens Newspaper*: 'It is proposed to form a football club for St Helens and neighbourhood. Gentlemen taking an interest in the game are requested to attend a preliminary meeting to be held at the Fleece Hotel on Wednesday November 19, 1873 at 7.30pm.'

So, St Helens Football Club was formed, and is one of the oldest members of the Rugby Football League. Herman was chairman. Rules were established and the use of Boundary Road recreation ground was secured. Their first match was on 31 January 1874 when the twenty-strong St Helens team lost to Liverpool Road Infirmary. They became known as the St Helens Rangers until the 1880s and moved from their City Road ground to Knowsley Road in 1890, where they won their first match against Manchester Rangers. They resigned from the Rugby Football Union in 1895 and became part of the new code, beating Rochdale Hornets. At this point their playing strip was a vertically striped blue and white kit.

The Challenge Cup was created in 1897 when St Helens played Batley in the first final, losing 10-3. From 1897 until 1901 they struggled to find success and promotion to the combined Lancashire and Yorkshire combined Division One in 1902/03 was short-lived. They were soon relegated. The war years were difficult for the game.

In 1956, Saints beat Halifax to take the Challenge Cup, which was followed in the 1960s with more success and the introduction of the red vee kit in 1961. In the 1970s they reached three Challenge Cup finals while the 1980s saw mixed fortunes, ending in a Challenge Cup defeat in 1989.

Since Super League was introduced Saints have proved to be a very successful team and moved to the Totally Wicked Stadium in 2012.

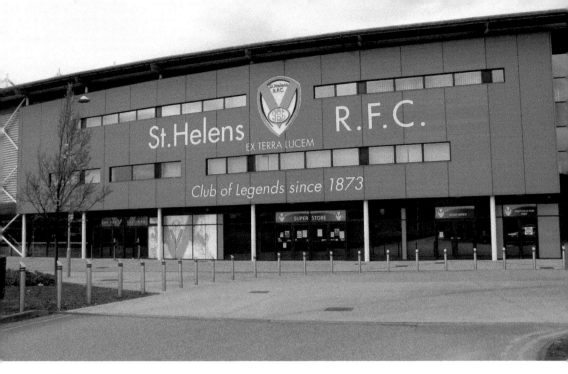

St Helens' rugby league ground.

Seddon, Richard

Richard John Seddon, who became the fifteenth and longest-serving New Zealand prime minister, was born at Eccleston, St Helens, on 22 June 1845. His parents, Thomas Seddon and Jane Lindsay, were teachers but that didn't prevent him from being removed from school at the age of twelve, having been described as 'unruly'. However, he had developed an interest in engineering and after a short time working at his grandfather Richard's Barrow Nook Hall Farm he started work at Daglish's Foundry, St Helens. He gained his Board of Trade Certificate in Mechanical Engineering while working at the Vauxhall Foundry, Liverpool, aged sixteen and, together with his brother Edward, aged fourteen, worked his passage to Australia aboard the SS *Great Britain*.

He worked in the Melbourne railway workshops but caught gold fever and went to Bendigo, returning empty handed. In Melbourne he met and became engaged to Louisa Jane Spotswood, the 'girl next door', but her family would not permit marriage until Seddon was financially secure. In 1866, Seddon, drawn by gold, moved to the West Coast of New Zealand's South Island. This time he was successful in Wairmea and married Louisa in Melbourne in 1869. They were to have nine children including Tom Seddon, who succeeded his father as MP for Westland.

Seddon entered local politics and became known along the west coast as a champion for miners' rights and interests. In 1877, he became the first mayor of Kumara, a gold-mining town. He entered the House of Representatives in 1879 where he followed an anti-elitist policy. In 1890, he joined the Liberal Party and he became premier in 1893. He was instrumental in implementing women's suffrage, introduced alcoholic licensing

Richard Seddon's cottage.

districts and introduced his Old Age Pensions Act (1898), which became the basis of the welfare state. Seddon was a great supporter of the British empire, although he twice refused a knighthood, wanting to be a man of the people. He attended Queen Victoria's Diamond Jubilee, received her Jubilee Medal and was appointed to the privy council. While attending the coronation of Edward VII and Queen Alexander he received his Coronation Medal and visited St Helens in July 1902 when he announced at a banquet in his honour that 'Aw've Coom Whoam'. He received the freedom of the borough.

In 1906, at the age of sixty, Seddon died of a heart attack on the ship *Oswestry Grange* while returning from Australia to New Zealand. He is buried in Wellington, New Zealand. There is a memorial to Richard Seddon in St Paul's Cathedral and in his home town a Seddon Close, Seddon Street and a Seddon Suite at St Helens Hospital.

(The) Stork Inn, Billinge

It is thought the building that occupied this site during the English Civil War (1642–51) once housed Oliver Cromwell's prisoners. The historic hostelry on Main Street was built as a farmhouse in 1718 and was extended in 1752 – this date is inscribed on

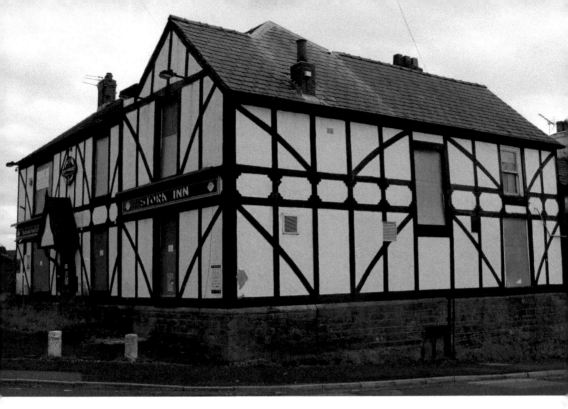

The Stork Inn, Billinge.

the keystone above the front door. It served as a toll tower on the main Liverpool to Lancaster Road and has been an inn and hotel. The earliest occupant who can be identified is Betty Howard, while Susannah Howard is listed as the landlady around 1881. In 1890, landlord James George Howard was accused of selling adulterated rum after his wife topped up a bottle with water in front of a plain clothes policeman. The case was dismissed. The next landlord was Hugh Mather and his wife, Elizabeth, who came here in the early 1890s. They rented the pub and the farm next door from the Bankes family and it became a stopping-off place for travellers. Hugh died in July 1912 of pneumonia. The Stork Inn has now closed but is reputed to be haunted.

Sutton

Sutton was another one of the four original townships and, although the origin of the name is unknown some sources say it may have come from 'south town'. Influential families such as Eltonhead, Ravenhead, Holland and Sherdley all owned land here.

Most of the township lay upon the coal measures of the South Lancashire coalfield. It is recorded that coal was being mined at Sutton Heath as early as 1556 when 'beds of cinders or coke ... have been discovered three-foot-thick during the digging of clay' on the Eltonhead land. As the Industrial Revolution progressed so did the demand for coal, and further pits opened up. For example, Charles Dagnall, an early investor, was operating Barton's Bank Colliery in Sutton/Watery Lane in 1750 and had built

a Newcomen Engine here. However, in 1839 the mine was put up for auction at the Raven Inn, Church Street, and there is no evidence of it being worked after this date.

However, Sutton had a legion of new pits, including Sherdley, Lea Green, Bold, Clockface and Sutton Manor, which became one of the biggest pits in the South Lancashire Coalfield, all of which opened between 1873 and 1901. Earthenware drainage pipes and watch movements production were also important industries.

Sutton Hall was the lord's manor house and was occupied by members of the Holland family for around 400 years. In 1558, Roger Holland was burnt at the stake at Smithfields after moving to London and abandoning Catholicism. He had been charged and convicted of heresy during the last months of the Catholic Mary I's reign. Father Thomas Holland, who in 1600 had been born at Sutton Hall, was found guilty of high treason during the Protestant Elizabeth I's reign. His crime was administering to Catholics for eight years; he was hanged and quartered on 12 December 1642. The Hollands and the Eltonheads had their estates sequestered following the Civil War after fighting on the Royalist side. Sutton Hall was demolished in 1935.

Sutton has two railway stations: St Helens Junction and Lea Green. Both operate services to Liverpool and Manchester. Sherdley Park was home to the St Helens Show, which between 2007 and 2010 was classed the biggest free show in Europe, and today Sutton is home to the *Dream* statue.

Sherdley Park, Sutton.

Sutton Oak Welsh Chapel

The St Helens copper-smelting industry was based on Welsh copper, much of it from the Parys Mine Company, Anglesey. This brought with it a skilled Welsh workforce and their families. The central point of these families was their Welsh Chapel meetings, which in the beginning had to be held in rented rooms and cottages in the town.

As the congregation grew in Sutton new larger premises were found at the Hole in the Wall Church – so called because the congregation had to pass through a hole in the wall around the Lancots Lane factory of Crohn & Taylor before entering the place of worship, which was a rented storeroom. Even when the copper industry had ceased expanding the congregation continued to grow, so that by 1892 a permanent church was needed.

This was to be the Methodist Chapel in Sutton Road, which had been built in Lancots Lane/Sutton Road in 1846. It was bought by the Welsh United Religious Church in 1893 for £180. The building is Grade II listed as it is one of the few to be constructed of industrial waste from the copper works, although the Sutton Road frontage is built from brick.

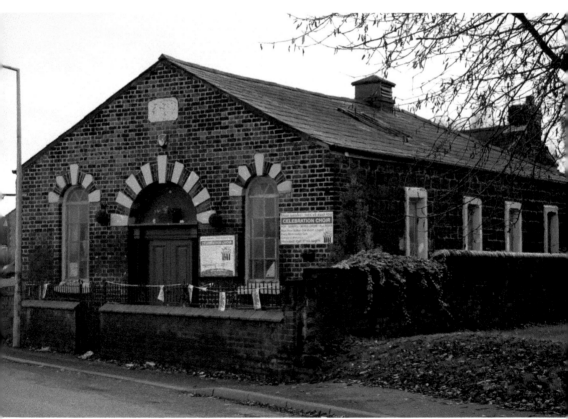

Sutton Oak Welsh Chapel.

Thatto Heath

Thatto Heath is mentioned in historic documents variously as 'Thatwell Heath', 'Thattow Heath' or 'Hatto Heath' and is a district of St Helens. In 1700, the area was mainly agricultural; tilled fields existed, as did arable and pasture farming. The gaps in the farming fields were given place names such as 'heath' as shown in the name Thatto Heath.

It was the scene of early coal mining, as in 1690 a Frodsham gentleman leased from the Crown (Queen Catherine of Braganza) and then bought part of Thatto Heath, bordering the Sutton and Eccleston townships. The land was drained and mining started here.

By 1718 the mine was a prosperous concern, although mining it fell into decline until the steam era of the 1770s when the collieries were revived by Scots industrialist John MacKay.

Other industries also found a home here. Although the first glasshouse, owned by John Leaf, is recorded in the Sutton township in 1696, it is believed it was in the Thatto

Thatto Heath Park.

Heath-Ravenhead area of Sutton. Another industry to be found here was brewing, which was owned by the Foster family.

As the area grew so did the facilities there, such as the Methodist Mission at Nutgrove built by Jonas Nuttall in 1811. Leisure was provided by Victoria Gardens, which had been opened in the 1840s by Charles Whittle, landlord of the Engine Inn, when he decided to create East Asian gardens on his wild land in front of the pub.

It put the area on the map as it became a middle-class attraction, hosting open-air dancing, singing, dining events and had its own resident band. A large dining room was built, and among its patrons were the Liverpool Masonic Lodge. When Charles Whittle died in 1875 the park went to new owners, but by the 1890s it had disappeared. It was replaced by housing, but its legacy carries on through the name Whittle Street.

The land for Thatto Heath Park was bought from the Crown in 1884 for £600 and opened the same year. It was the town's first park.

Titanic

There are several connections between the ill-fated liner that sank in 1912 and St Helens. One of these is the ship's captain, Edward John Smith, who was born in January 1850 at Hanley, Stoke-on-Trent, and married Eleanor, the second daughter of Mr William Pennington from Woodhead Farm, Newton-le-Willows. The captain and his wife lived in this area before going to Waterloo, Liverpool and then to Southampton. Smith, who went down with the ship, had a distinguished army career in the Boer War commanding troops in the Cape. He was the first to command the *Titanic*'s sister ship, the *Olympic*. His wife Eleanor, who was born in 1861, stayed in Southampton but later moved to London. She was knocked down and killed by a taxi on 28 April 1931 while standing outside her home.

Chief steward on the liner was Andrew Latimer, who drowned in the sinking. He lived in Earlestown, although he had been born in Lancaster in 1857. His mother had a shop in Market Street and his first wife, Emily Hewitt Wolstenholme, was from Newton. They married on 26 February 1880 and had three children – Mary, Margaret (known as Madge) and George – and they lived near the Oak Tree pub. After his first wife died he married again and moved to Waterloo, Liverpool. His body was never recovered.

Charles Frederick Waddington Sedgwick was a twenty-five-year-old electrical engineer from Aigburth and boarded the *Titanic* as a second-class passenger. His last job had been with the St Helens Electricity Works, where he worked for four years. He died in the sinking and his body was never recovered.

John Frederick Preston Clarke was born in Chorlton, Manchester, on 28 July 1883 and was one of the eight musicians who played on the *Titanic*. He lived in Liverpool but had played in the St Helens Musical Society Orchestra on many occasions. He died in the sinking. His body was recovered, and he is buried in the Mount Olive Cemetery, Halifax, Canada.

Thomas Lawrenson was born in St Helens on 18 August 1889. His parents were Arthur, a miner, and Margaret. In February 1907 he enlisted as a stoker with the Royal Navy, making himself a year older on his application so that he could do so. He worked on many ships until February 1912 when he went ashore until his next job on the *Carpathia* in April 1912. He was on board when the ship rescued survivors of the *Titanic*. He lived in Frederick Street, Liverpool, with his wife Catherine and their six children. He continued to work at sea and prior to the First World War served with the Merchant Fleet before reenlisting with the Royal Navy. He died in April 1924 and is buried in Anfield Cemetery and Crematorium, Liverpool.

Tontine Street

In 1797, the St Helens Tontine built a row of cottages that was the first completely new street in St Helens. Eventually Market Street would link this street with the busy Church Street. Tontine Street was the heart of the fast-growing industrial town.

A Methodist chapel was built here in 1815 and, as the century progressed, property ownership increased, as shown by James Shepherd, a grocer who died in the 1830s and owned two houses and shops and five cottages in Tontine Street.

In 1820 a sail cloth factory owned by Thomas and William Kidd was here. It closed in the 1840s.

By 1895 business was flourishing and among the premises to be found here was a newsagent, hairdresser, timber merchant, coal merchant, watchmaker, bird dealer, dressmaker, saddler, estate agent and a china dealer. There was also no shortage of inns and public houses, such as the Churn Inn, Robin Hood, Queen's Vaults, Seven Stars and, despite its name, the Tontine Coffee House. The street was demolished to make way for what is now Church Square Shopping Centre, but the name lives on through Tontine House, No. 24 Church Street.

Tontine Street.

U

United Glass

The history of this company lies in a public company named the United Glass Bottle Manufacturers Ltd, formed in 1913 when Ravenhead Glass, Cannington Shaw & Co., Nuttall Co., Alfred Alexander & Co. and Robert Candlish & Son amalgamated. These companies came together so they could raise enough capital to acquire rights in the first successful automatic bottle-making machine, which had been invented by Michael Owens, the founder of Owens-Illinois Inc.

The company closed some smaller plants and concentrated its production at a newly built factory at Charlton and the two St Helens factories, at Sherdley. According to Grace's Guide, in 1922 an advertisement was placed, stating: 'Use Good Bottles. 250,000,000 British Made Bottles Per Annum. U. G. B. Bottles are:- Accurate in Capacity; the Corkage is Correct; the Height and Shape are Uniform; the Strongest Bottles Made. (Stand Nos. G.24 and G.40).'

Before 1931 the companies were primarily bottle makers, but they expanded to produce bowls, jugs and drinking glasses, some featuring art deco influences.

In 1959, United Glass Ltd started making plastic bottles at their subsidiary, United Glass (Thermoplastics). The Sherdley factory closed in 1964 and tableware production transferred to the Ravenhead Glass factory. The new factory at Peasley Cross began bottle production until 1999 when it closed. The Ravenhead Glass factory, Nuttall Street, closed in 2000.

Vimto

The popular drink Vimto is made by the Haydock-based Nichols plc, although it dates back to 1908 when its creator John Noel Nichols (1883–1966) started its production.

Nichols was born in Blackburn on 29 December 1883 and was a wholesaler of spices, herbs and medicines. The drink started life as Vim Tonic and was billed as a herbal tonic made to give people vim and vigour.

Nichols took it to small outlets such as cafés and temperance bars and it became known as Vimto. The company grew and in 1910 left the herbal business in Manchester and went to Salford.

Its trademark was registered in Guyana in 1919 and the company's international department began; today it exports to seventy-three countries. In 1950, its first black-and-white TV advert was aired, and fourteen years later the new colours of red, white and blue were launched. It moved into the American market in 1970 and in 1992 a monument to Vimto, by Kerry Morrison, was unveiled at Manchester University.

W

Windle

Windle was one of the original townships and was also known as 'Windhull' (1201) and 'Windhill' (1320). The name comes from 'windy hill'. The original manor of Windle was granted to Pain de Vilers, 1st Baron of Warrington, but the land would pass to the de Windle family in the early thirteenth century. It then passed to the Gerard family of Brynn in the fourteenth century. The Colleys (Cowleys), Hindleys and Urmstons were also influential families in this area.

In the eighteenth century, Cowley Hill, Gerard's Bridge, Hardshaw, Islands Brow, Laffak, Moss Bank, Pocket Nook, Windle Ashes and Windle Smithy were all part of this township.

Adam Martindale, a Puritan who was born in Moss Bank in 1623, kept diaries of daily life here.

Windle Hall, which is set in 6 acres of gardens with its own woodland, was built in 1782 and leased to Dr William Pilkington. The Pilkington family continued to live here until the death of Lady Mavis Pilkington in 1998.

The Gerard's Bridge area, which was once part of Windle. This is the north-east side of the station, showing the Haresfinch Road bridge.

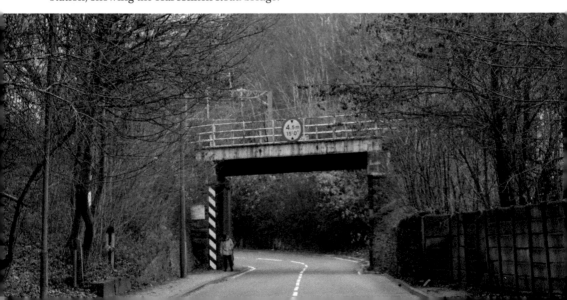

Windleshaw Abbey

The ruins of Windleshaw Abbey are in the borough cemetery and are also known as the Chapel of Saint Thomas of Canterbury. It is the oldest building of worship and oldest ruin in St Helens. The chapel, which is near Abbey Road, was founded as a chantry chapel by Sir Thomas Gerard of Bryn in around 1453. Here a priest would 'celebrate for the souls of the founders antecessors for ever'.

It was built of locally quarried sandstone and has a 36-foot-high tower. There are many interesting graves, including that of Jean de la Bruyere, who came here from St Gobain in 1739 to manage Ravenhead glassworks. There is also the grave of three infants of the Orrell family, who died of smallpox in 1782 and 1785. Following the Reformation, it fell into decay and in the early seventeenth century it became a Catholic burial ground, which was enclosed in 1778. It became part of the borough cemetery in 1856.

There is a story that officers in Oliver Cromwell's army enjoyed hospitality in the Windleshaw Abbey House, Dentons Green Lane, while some of their men were stripping the lead off the chantry roof to make bullets.

Today the remains are of the west tower and part of the walls of the chantry

Windleshaw Abbey.

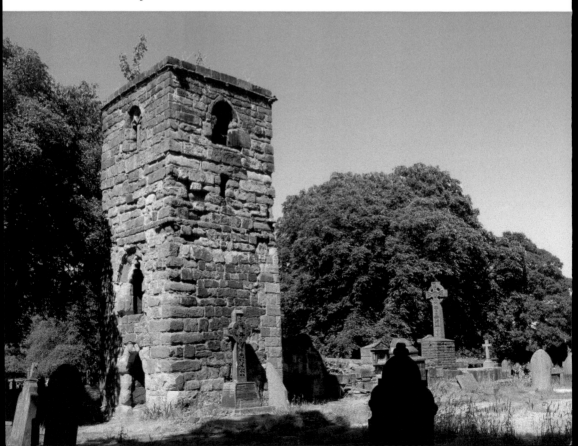

Worker's Memorial

The *Worker's Memorial* is in Vera Page Park and was unveiled on 28 April 2019, which is International Workers' Memorial Day, when workers killed, disabled, injured or made unwell by their work are remembered.

The statue shows an industrial worker holding aloft a child and was made by the Slovakian artist Martin Galbavy, who is based in Dorset. It has been created from old tools that were gathered from the St Helens area. Some had been passed on from father to son or tradesman to apprentice and have historical significance to the town. It is fenced in by railway lines and sleepers and the cobbles are from Dock Road, Liverpool.

The plaque reads: 'Dedicated to the men, women and children who have lost their lives through accident or illness caused by their work.' There is also a quote that says, 'We are what we are today because of yesterday.'

At the opening ceremony a specially made cloak of purple ribbons was draped over the statue in respect of the purple forget-me-not flower, which is the flower of Workers' Memorial Day. The park site was formerly Lyons Yard which was a nineteenth-century transport centre with many rail links and some sidings that terminated on the side of the Sankey Canal.

Worker's Memorial.

World of Glass

The World of Glass was founded in 2000 and combines the former Pilkington Glass Museum, which was relocated from the company's head office at Prescot Road and St Helens Borough Council Collections. The purpose-built museum was constructed over the remains of the Daglish Foundry, which was established in 1798. It is adjacent to the Pilkington glassworks and the Hotties, part of the Sankey Canal. It cost £14 million to build and Sir Antony Pilkington, former chairman of the Pilkington Glass Company, was one of the VIPs to attend the opening.

The site encompasses the Jubilee Cone Building, which is connected by a glass bridge to the rest of the building, a café and shop and two main galleries. The Glass Roots Gallery illustrates glass history with artefacts dating back to 3000 BC. The Earth into Light Gallery traces the history of St Helens and its role as a worldwide glass giant. The St Helens Past section recreates Victorian St Helens. There are more than 7,000 artefacts in the museum. There are also live glass-blowing demonstrations and courses.

There is a 2-tonne glass chandelier from the main hall of Manchester Airport, which was rehung here in 2008. It is one of four restored by David Malik & Son and contains 1,300 smoked grey and amethyst lead droplets, each individually blown by master craftsman Bruno Zanetti. Each chandelier cost £3,000 when commissioned in the 1960s. There is also the Clare Island Lighthouse Optic from Ireland's West Coast. This was made by Chance Brothers, Birmingham, in 1913. This company became part of Pilkington in 1981, but in 1992 reverted to the Malvern Chance plant. When the lighthouse was decommissioned in 1965 the optic was relocated to the Pilkington Glass Museum and then the World of Glass.

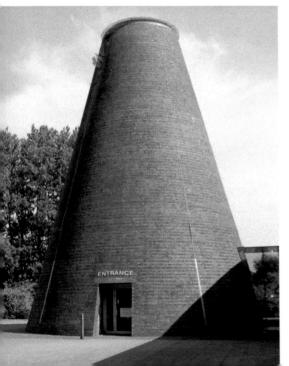

The World of Glass.

World Records

St Helens has had its fair share of world record holders, and Tom Colquitt, who was born in Parr Mount in the nineteenth century, was just one of them. Tom was a 'novelty' jumper, who became world champion in jumping backwards when he exceeded the 60-foot 6-inch mark for six backward jumps. He also attempted the 81-foot record for eight backward jumps. He started his road to fame by leaping over Blackbrook Canal, St Helens, which is between 20 and 35 metres wide. Another of his amazing deeds was to stand-jump over horse-drawn hansom cabs.

In another of his spectacular feats he was set to give an exhibition of ten spring jumps with weights. In order to make it more interesting a gold medal was offered for any local challenger who succeeded in beating Tom's mark and they would get a 15-foot start. Tom also defeated his arch-rival and multiple British jump championship winner Joseph Darby in Bury in 1898.

Another world champion was Geoff Duke OBE, a motorcyclist who was born in Duke Street, St Helens, on 29 March 1923. He was educated at Cowley Prep and Grammar School and started riding motorcycles as a youngster. He served during the Second World War, reaching the rank of sergeant in the Royal Signals; he was demobbed in 1947.

In 1951 he achieved his first world championship as a motorbike rider in the 500cc and 350cc events. This year he also became the Sportsman of the Year (forerunner to BBC Sports Personality of the Year). He achieved further World Championships in 1953, 1954 and 1955 – the first World Championship hat-trick. After retiring he settled in the Isle of Man, dying in 2015 at the age of ninety-two.

Duke Street.

Xmas

There is a long history of Christmas traditions in St Helens, including open-air markets, Christmas trees and cribs, nativity plays and, of course, pantomimes. Christmas Day and Boxing Day became bank holidays following the Bank Holiday Act of 1871, although Christmas Day had long been recognised as a day off. Boxing Day

Xmas lights.

was one of four new bank holidays introduced with this Act. The others were August bank holiday Monday, which was then the first Monday of that month, Easter Monday and Whit Monday. For a while these collectively became known as St Lubbock's Days after Sir John Lubbock, who introduced the Act.

In the early twentieth century in St Helens, goose was used more often than turkey for the Christmas meal and, although these were supplied by farmers, many people reared their own birds either in their backyard or on communal land. The plucking and preparation of the birds was done by hand by family members.

Pantomime has also been a strong tradition in the town; for example, the second Theatre Royal (later Citadel), Waterloo Street, played host to the famous music hall star Vesta Tilly. She starred in their first pantomime *The Babes in the Wood*, which opened on Boxing Day in 1884. The Hippodrome Theatre, now a bingo hall on Corporation Street, and the Citadel Arts Centre also staged pantomimes. Today the Theatre Royal carries on this tradition. Among the starts to appear here was Stephen Lewis who played Blakey (Inspector Blake) in *On the Buses*.

YMCA

The St Helens YMCA, now located at No. 2 North Road, was established in 1886 following the founding of the organisation in 1844 by George Williams. He was a worker in the drapery trade in London who was concerned about the welfare of his fellow workers and so started a prayer and Bible study group. This drew men from across London and the YMCA began to address workers' concerns nationwide, including those in Manchester. They introduced public lectures, education classes, reading rooms and refreshment areas to help young men.

In 1887, the St Helens branch moved to Hardshaw Street and three years later to a Literary Institute and Gymnasium built on College Street and Duke Street in St Helens. In 1903, they moved to the YMCA building, North Road, St Helens, which was opened by the Earl of Aberdeen. Today College Street is home to the Beacon, their nursery base and home of Y Sports. The YMCA is a worldwide organisation with 45 million members.

YMCA.

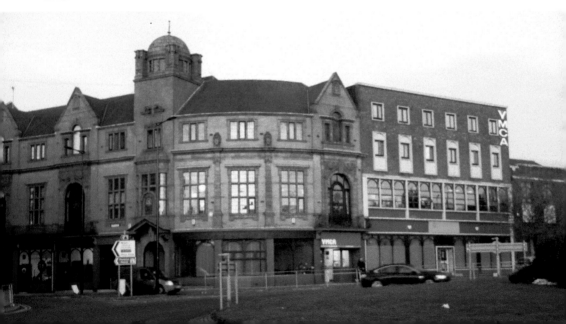

Z

Z Cars

One of the stars of the TV police drama *Z Cars* was Colin Welland, who played PC David Graham from 1962 to 1965, featuring in eighty-five episodes. The BBC programme ran from January 1962 to September 1978, with a total of 801 episodes. Colin Williams, his birth name, had strong connections with St Helens, although he was born in Liverpool in 1934. His family moved to Newton-le-Willows when he was young and he attended Newton Grammar School, later becoming a teacher.

He became an assistant stage manager for Manchester Library Theatre which led him to *Z Cars* and the role of Mr Farthing in *Kes*, for which he won a BAFTA. He acted alongside Richard Burton and Dustin Hoffman, but was also known as a writer, winning a BAFTA for *Kisses at Fifty*. He won an Oscar for the Best Original Screenplay for *Chariots of Fire* in 1982 when he made his famous 'the British are coming' acceptance speech. He returned to the area when he opened Newton-le-Willows Jobcentre. He died in 2015 at the age of eighty-one.

Bibliography

Books

Barker, T. C. and J. R. Harris, *A Merseyside Town in the Industrial Revolution: St Helens 1750–1900* (London: Frank Cass, 1954)

Brooking, Tom, *Richard Seddon King of God's Own* (New Zealand: Penguin, 2014)

Free, F. W., *Our Heritage Parr*

Handley, Maurice and Paul Rees (editors), *A Guide to the Industrial Heritage of Merseyside* (Merseyside Industrial Heritage Society, 2020)

Harrison, Annie, *A Promise Fulfilled* (1977)

History of Nursing at the Manchester Royal Infirmary (Manchester University Press, William Brocklebank, 1970)

Norcross, Derek, *The Provision of Education in the St Helens Area 1833–1902* (Manchester: 1973)

Presland, Mary, *The Story of the Sundial*

Risley, David and Richard Waring, *St Helens Pals* (St Helens Townships History Society, 2014)

Senior, Geoffrey and Gertrude Henin, *St Helens As It Was* (Nelson: Hendon Publishing Company Limited, 1973)

Sheen, Frank, *St Helens in the Making* (Coventry: Jones-Sands Publishing, 1993)

Sheen, Frank, *The Way We Were* (Wirral: Jones-Sands Publishing, 1995)

Victoria County History

Websites

beatlesbible.com

gracesguide.co.uk

ludchurchmyblog.wordpress.com

medievalgenealogy.org.uk

st.helens.gov.uk